GUESSWHO

the many faces
of **NOMA BAR**

introduction **STEVEN HELLER**

mbp

Guess Who
the many faces of Noma Bar
by Noma Bar

Design & Production
Noma Bar
Christopher D Salyers
Eliane Lazzaris

Editing
Buzz Poole

This book is typeset in Futura Maxi.

Library of Congress Control Number: 2007921478

Printed and bound
at The National Press,
Hashemite Kingdom
of Jordan

10 9 8 7 6 5 4 3 2 1 First edition

This edition © 2007
Mark Batty Publisher
36 W 37th Street, Penthouse
New York, NY 10018

www.markbattypublisher.com
www.nomabar.com

ISBN-10: 0-9779850-7-5
ISBN-13: 978-0-9779850-7-4

Distributed outside North America by:

Thames & Hudson Ltd
181A High Holborn
London WC1V 7QX
United Kingdom

Tel: 00 44 20 7845 5000
Fax: 00 44 20 7845 5055

www.thameshudson.co.uk

GUESSWHO

the many faces
of **NOMA BAR**

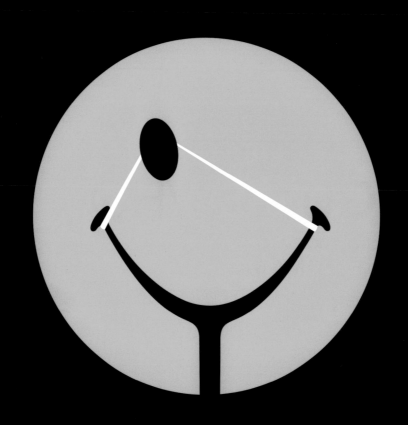

INTRODUCTION
STEVEN HELLER

Landing devastating body blows rather than light facial jabs separates great boxers from mediocre ones. The same is true for caricaturists, yet for most, pounding epidermal layers into goofy distortions is much easier to achieve. Although clichés like big heads on little bodies, huge lips, bushy eyebrows, and bulging eyes are always crowd pleasers, a truly smart caricature reveals the victim by using symbol and metaphor to unhinge their facades. What use is this strident art form – born of a Renaissance desire to plumb below the surface and uncover inner, sometimes devastating truths – if no one is victimized? Merely making someone clownish is only a small part of a great caricaturist's ability, and overall artistic responsibility.

The most memorable – and valuable – caricatures throughout history are those that have insightfully ravaged and savaged; they take no prisoners and leave only iconic carcasses behind. Of course, not all persons ripe for caricature deserve to be so abused but neither should they be turned into silly irrelevancies either. Albert Einstein is not inhumanly venal like Joseph Stalin nor is Luciano Pavoratti dangerously incompetent like George W. Bush, yet Einstein and Pavoratti have stature that demands the same standard of graphic diligence as levied on the most horrific despots and presidents, even if the aims of these caricatures are celebratory not vituperative. And it takes a great caricaturist to know how to do both.

Enter Noma Bar, an equal opportunity caricaturist. He bears down on Einstein (pg 12) and Pavoratti (pg 126), as well as Ozzy Osborne, Stephen King, and Stephen Hawking, among other iconic celebrities in this book, with the same visual acuity – at times an equal lust for the jugular – as he does in his caricatures of Kim Jong II,

Yasser Arafat, and, yes, George Bush. Without resorting to cheap conceits, he extracts pictographic essences of each individual – ballistic missiles for Kim's eyes, a radioactivity symbol for Hussein's nose and mouth, and the tortured, electrocuted Abu Ghraib prisoner replaces all of Bush's facial features – to brand their respective personality flaws into the audience's consciousness. Unlike the masters of late twentieth century caricature – including David Levine, Edward Sorel, Robert Grossman, Ralph Steadman and Roger Law, who have long practiced physiognomic distortion with surgical precision – Bar achieves his version of ritualistic unmasking with recognizable components that speak to the character of the caricatured. These aforementioned veterans (and their acolytes and imitators) sculpt the human form, like so much malleable clay, into comically charged portraits, while Bar more intricately designs physical way-finding systems influenced, in large part, by the stark graphics of international, directional sign-symbols found in airports and other public spaces. With this manner he has staked out a niche in a unique sub-genre of caricature.

Indeed his caricatures are not designed always to ridicule his subjects but rather isolate either their negative or positive attributes depending on who is the subject (the broken chain links that form Nelson Mandella's facial features serve to underscore the viewer's pathos for this heroic figure (pg 82), while the small child that forms Michael Jackson's eyes and nose suggest his alleged dalliances with prepubescent boys (pg 124)).

Admittedly, this iconic approach is not entirely unique. It goes back to the late eighteenth century and has been modified frequently since. In fact, building on a foundation of one such modification by Israeli illustrator Hannoch Piven, who starting in the early

nineties cleverly employed three-dimensional objects as facial features, Bar practices his pictorial alchemy by commixing visual puns and realistic form in a vivid graphic way. His contemporary use of stark flat color and bold silhouettes distinguishes his approach from the overly rendered and collage methodologies.

Bar, age 33, was born in Israel, yet has been based in London since 2000. He's made caricatures, he says, as a "communication tool" since kindergarten and routinely sketched charged portraits of his teachers at school, commanders in the Israeli Navy and tutors in art school for both fun and emotional release. In Jerusalem he studied graphic design at the influential Bezalel Academy of Art & Design where he combined the arts of typography and illustration. His artistic awakening – and eventual signature style – came when he left Israel for England and the move from his native Hebrew to English was a big shock. He blames the loss of his verbal capacity to be witty and playful with words for "why pictograms came into my work and became part of my vocabulary." But the seeds were planted much earlier; in fact, during the first Gulf War, when he was seventeen and while hiding in the air raid shelters he read an article on Saddam Hussein and his alleged nuclear weapons. It was at that moment he saw in the ubiquitous radioactive icon two eyebrows and a mustache. "It became a rough sketch in one of my early sketchbooks. Years later, while Saddam was still in the headlines and just before Iraq Two, it all came back to me," he recalls. "My rough sketch was revived and it was one of my first caricatures that printed as a limited edition. When my father saw the printed result he smiled and said: 'Good one, it doesn't happen everyday, so what's next?'" Given this paternal challenge, Bar continued to search the faces of all his heroes and villains for their respective facial logos.

The time he spent commuting in the London Underground proved a fine way to exercise his newfound prowess. In each carriage he'd relentlessly sketch other passengers, and the opportunities were infinite. "I'll start a drawing of someone, turn my head for a split moment and someone else will sit there, in the same position with a different story," he explains. Other London influences include Camden Town, where he's lived for five years, and where Punk was born and cyber Goth later developed. He savored the wired hybrid of English Goth, American Heavy Metal, Manga cartoons and Punk: "Where The Adams Family met Hello Kitty. Observing the pale faces with black hair and make up – such an amazing contrasts, the facial features almost floating in the space of the skull." He acknowledges that these visual images pushed his work towards black and white, or using black and a second color.

Another, although less overt, influence is Charlie Chaplin for his pantomime. (And what is caricature but a form of pantomime?) He also admires Salvador Dali for teaching him that "Nipples can see, bellybuttons can smell, and pubic hair can smile." The British designer, Alan Fletcher, who died in 2006, taught Bar how negative space can be positive – and so it is. But the most unique influence is Pesah Gutkevitz, a neighbor back in Israel, who owned a tractor repair shop, but when he retired decided to become an artist. Bar's small, sleepy Israeli town became an alternative gallery to Gutkevitz's wired art. He used car wheels mounted into chains with a few metal bits on the side, creating big chunky pieces of iron, colored badly with black brush, which were deposited around the town. "Pesah was my introduction to ready-mades and to objects that can live again and again."

Bar is further captivated by dots (two of them to be exact): "I like two dots! Just two small dots, floating one next to the other. They are nothing but everything at the same time." Just look at his work with that in mind and those damn dots jump off the pages. Add this to his fascination for modern dance (his wife is a former ballet dancer who introduced him to the principles of movement, exploration of space, gravity, tension, the body as a communication tool) and one can see how he creates, what he calls, "dialogues that are not verbal." From these dialogues evolve the iconic pictograms that tell their respective stories with only a few graphic lines.

When asked what political, social or cultural issue triggers the most curiosity, or ire, for his caricature, Bar replies that generally speaking what's most important to him is "the story, then idea, and then the facial structure." If the person in his crosshairs represents an issue or ideology he can grab hold of, and the face is also iconic, "it will make my work effortless."

Nonetheless, don't take this statement at face value; his work is decidedly complex. Achieving the perfect match of symbol and character, producing the quint-essential evocation of an individual through a few stark linear marks is never effortless, even if Bar makes it seem that way.

CULTURAL
ICONS

**ALBERT
EINSTEIN**

Commissioned by *The Economist* for a cover
story about 100 years of Einstein. Though the
illustration was never printed, Bar considers this a
perfect example of combining two icons, which
results in something that is "almost like a logo."
Einstein's famously unkempt hair and the atomic
symbol, with two molecules as eyes, form this
famous face.

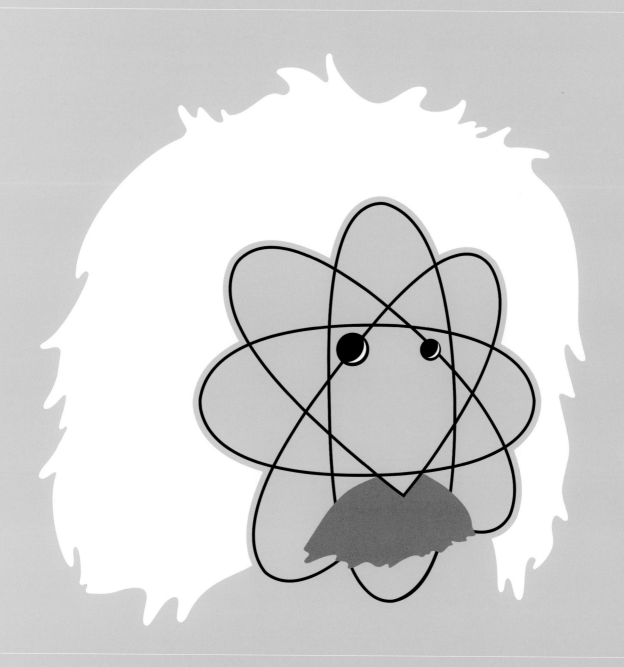

Bar considers his approach to these illustrations as "telling short jokes." With as few lines as possible, he limns a person's career, rendering "what their lives are." Here, Bar incorporates Hawking's career as a leading theoretical physicist with his Amyotrophic Lateral Sclerosis, the motor neuron disease he has lived with most of his adult life: slightly canted head, a planet for a mouth and a blackhole eye.

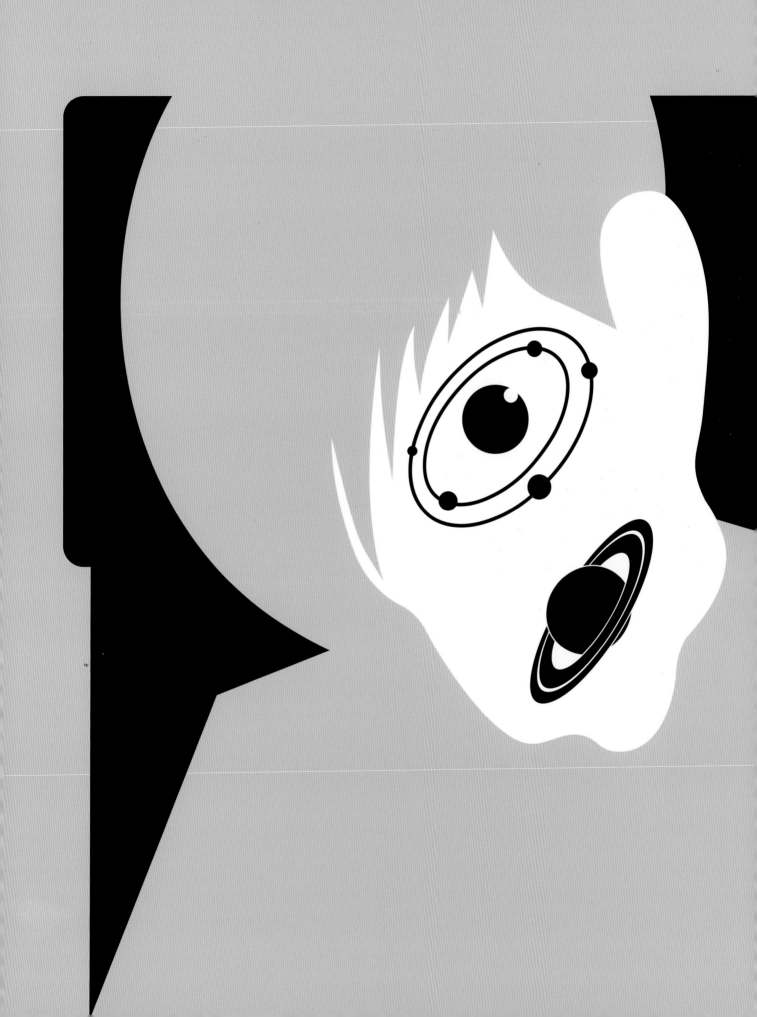

WILLIAM SHAKESPEARE

Q

What was the first face that you got published?

A

It was a full page for *Time Out London* related to a feature article about a BBC program called "The Search for Shakespeare." The show revolved around new biographical discoveries and all the questions these raised. I received this commission about 5 hours before a flight to Italy. All of a sudden the question mark idea linked the theme of the program to one of the most significant philosophical questions of all time: To be or not to be? I chose "to be" and sent the final portrait off about two hours after receiving the assignment.

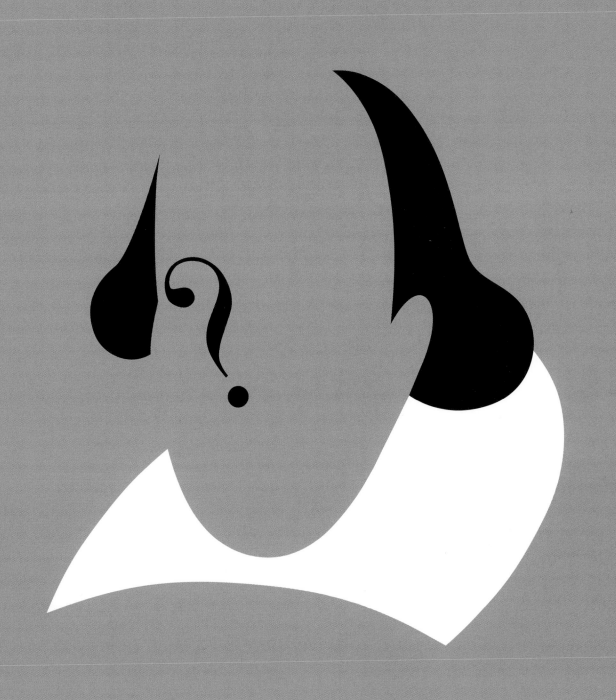

**STEPHEN
KING**

Before Bar draws a personality, he studies
photographs, films, aspects of the personality's
career and other illustrative references. By their
very nature, caricatures are over-exaggerated
looks at people. In this case, Bar could not get
away from the unusual amount of space
between Stephen King's nose and mouth. The
hatchet eyes drip blood, which gives the sense
of a nose. The bloody slit of a mouth furthers the
metaphor, appropriate for the world's most
successful horror writer.

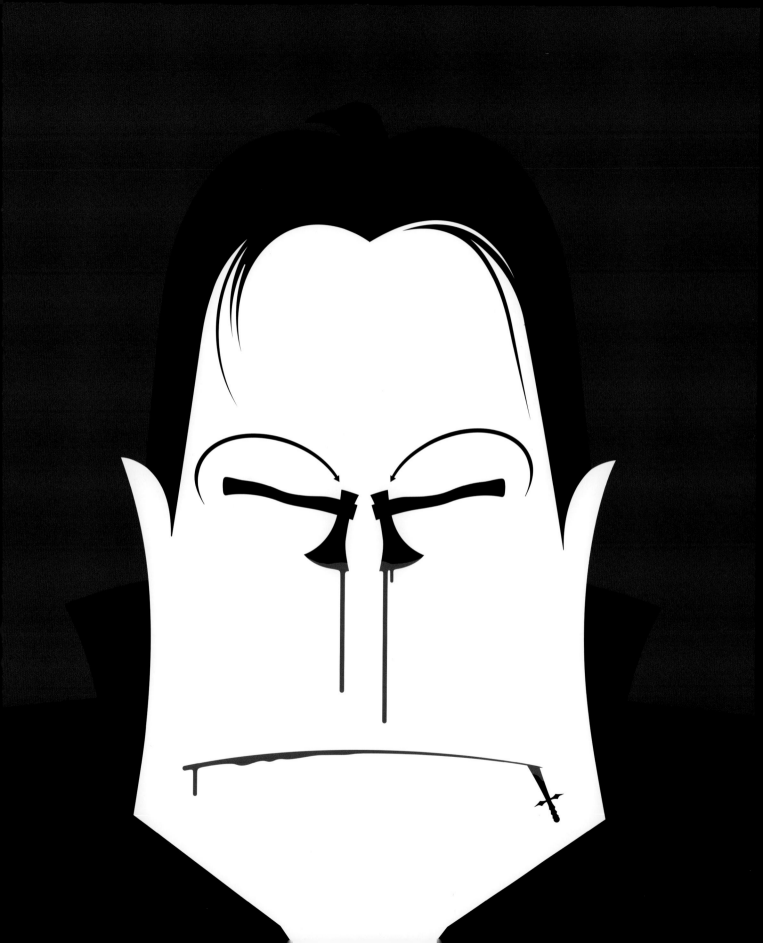

When Peaches Geldoff (daughter of honorary
knight and musical impresario Bob Geldof) wrote
an article about her email relationship with JT
Leroy for *The Telegraph*, this illustration ran with
the piece. In the wake of the discovery that
Leroy, who had claimed to be a man, was in
fact a woman (and a pseudonym), the media
had a field day. Bar deftly converted the face
into a female torso, turning Leroy's sunglasses
into a bra. He's not a man, man!

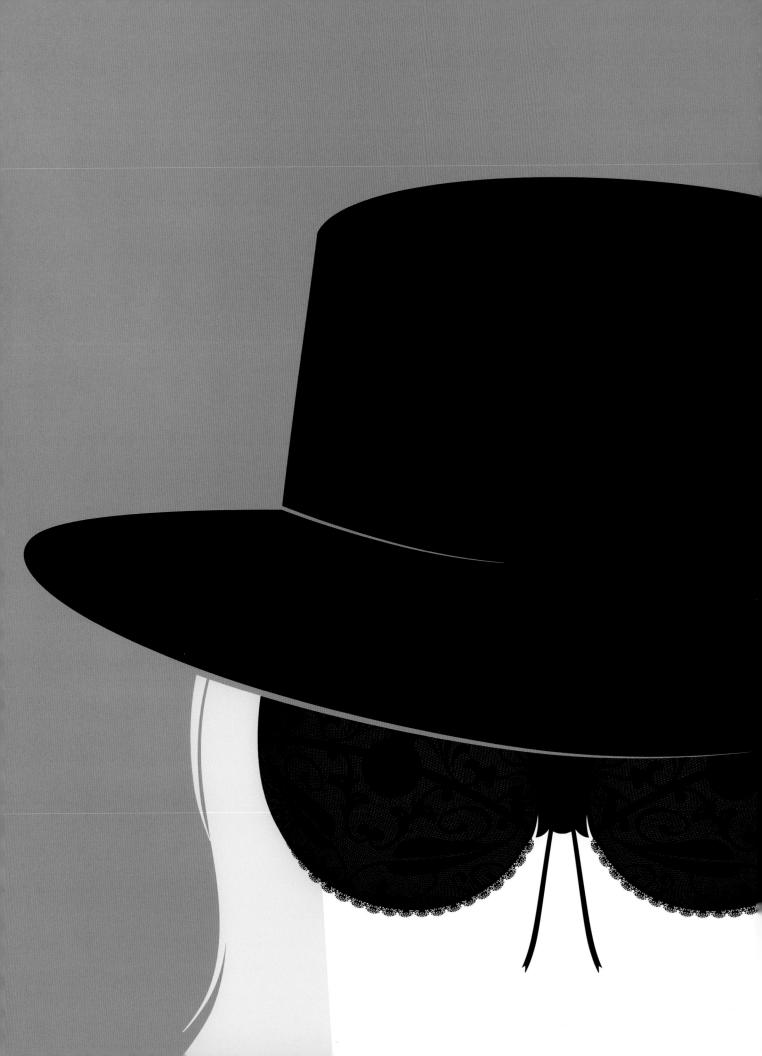

NICK
HORNBY

A bald guy that likes to makes lists of records and books he likes. How hard can that be to render in a fun and creative way? Well, this illustration of writer Nick Hornby required close to 200 drafts! Bar admits that bald people make his job harder; it is an issue of a "unique graphic balance." Bar knew he wanted to use a turntable as part of the portrait, and finally, hinging the concept on Hornby's nostril, the way to execute the concept became apparent. The mouth becomes the edge of a record, the arm pivoting from his eye.

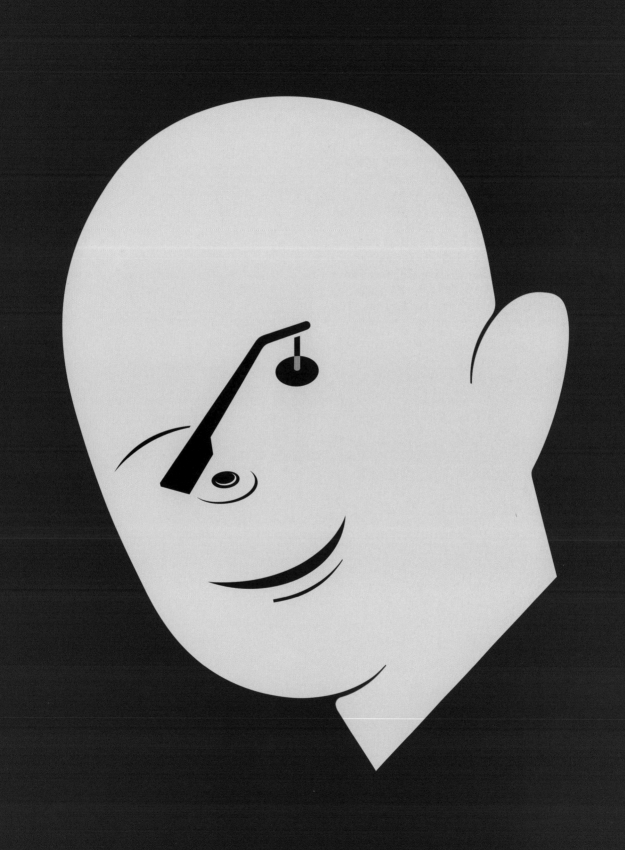

URI
GELLER

It makes sense that a Bar image of a man whose notoriety is based entirely around the ability to bend spoons with nothing more than mind power would use a spoon as the focal point. But for Bar, the real delight of this image is the hair. Uri Geller's hair reminds Bar of plastic milk bags like the ones so common during his childhood in Israel. Of course, this is not an association that anyone would simply make, but it is valuable insight into Bar's process, and that is, after all, what this is all about.

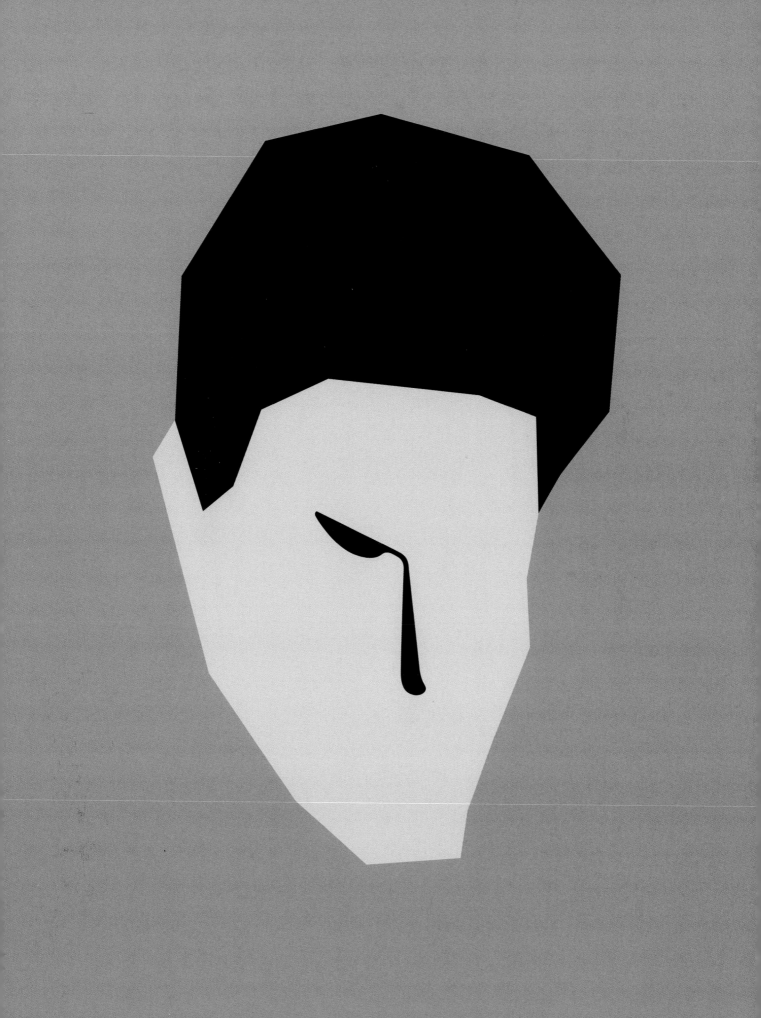

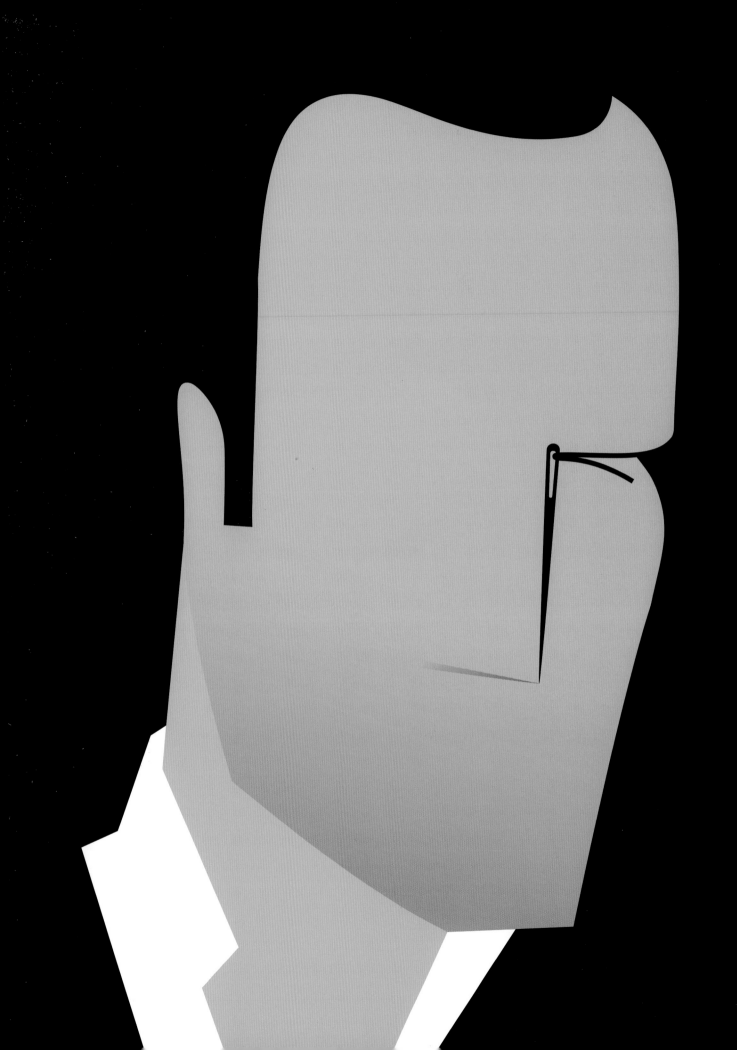

Texas-born, international fashion guru Tom Ford is known for his constantly stubbled, chiseled chin and white button-down shirt, a couple of the top buttons tantalizingly undone. After having a go of selling scripts in Hollywood, this former creative director for Gucci and Yves Saint-Laurent opened his first store in April 2007, on Madison Avenue in New York City. A not to miss shopping experience if you are in the market for velvet slippers, or the latest in mannered hunting apparel.

Q
Do you tend to identify objects that are emblematic of a person's career or life and then try to fit them into an actual face?

A
My favorite projects are the ones where the subjects are known for something, whether famous or infamous. If that characteristic is something everybody knows about, I follow that direction, and it helps me focus on the execution of the illustration.

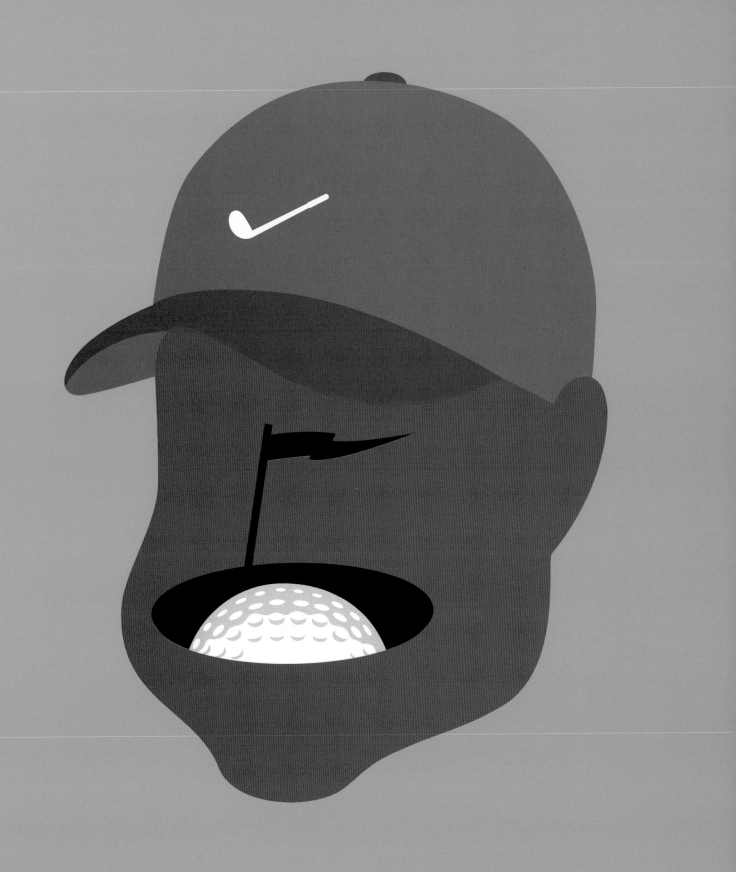

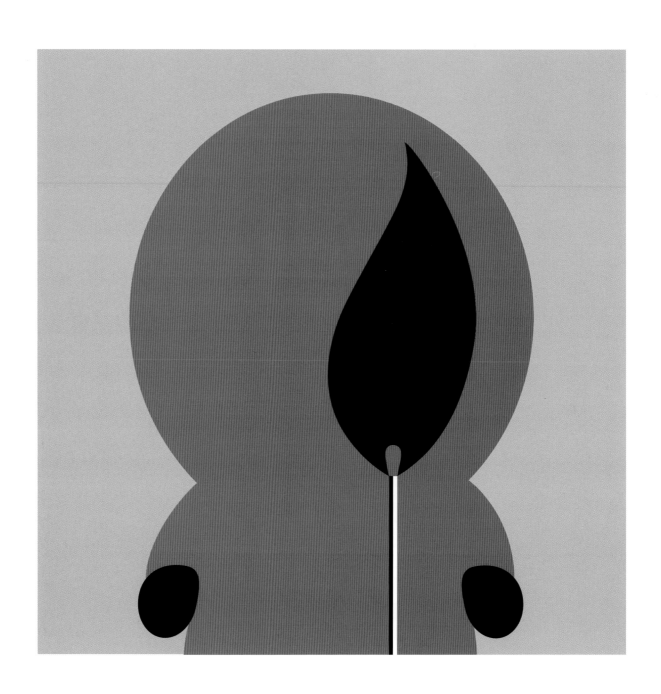

For a number of seasons, Kenny, one of the most popular *South Park* characters, died during every episode. Then he died for the last time. Then his soul was trapped in another character's body. Then he returned, again. Any way you look at it, Kenny is a specter of death. Fire killed Kenny more than once, hence Bar's decision to use a burning match in place of Kenny's face.

We've all been exposed to the Harry Potter hype. The success of this image is how it speaks directly to the fictional Harry Potter story, as well as the reality of this multi-million dollar industry. The centerpiece of the illustration is the wand, which evokes fanciful magic, as well as the almighty dollar.

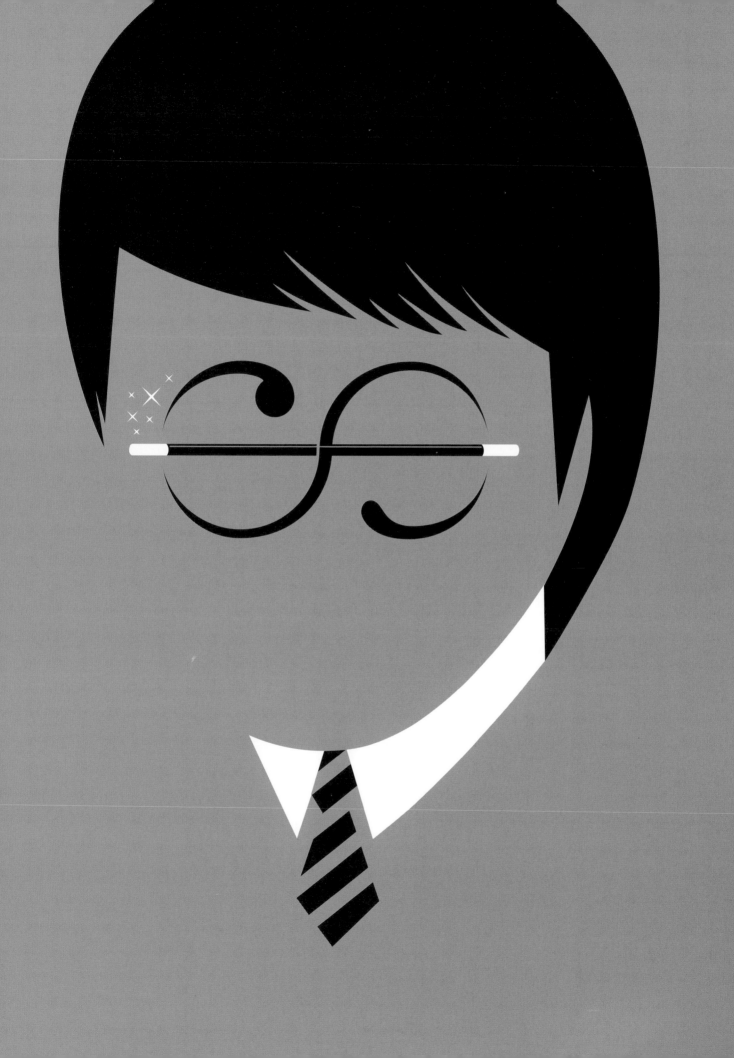

HOLLYWOOD
HEADS

**WOODY
ALLEN**

This illustration was done for an article about Woody Allen's film *Match Point*, which was shot in London. Bar's use of London architectural landmarks for the legend's already iconic face is a unique and effective touch. Nicknamed the gherkin, for its resemblance to a pickle, this noticeable Norman Foster building replaces Allen's nose; the Tate Modern forms an eyebrow over one of the skyline's newest structural icons, the London Eye.

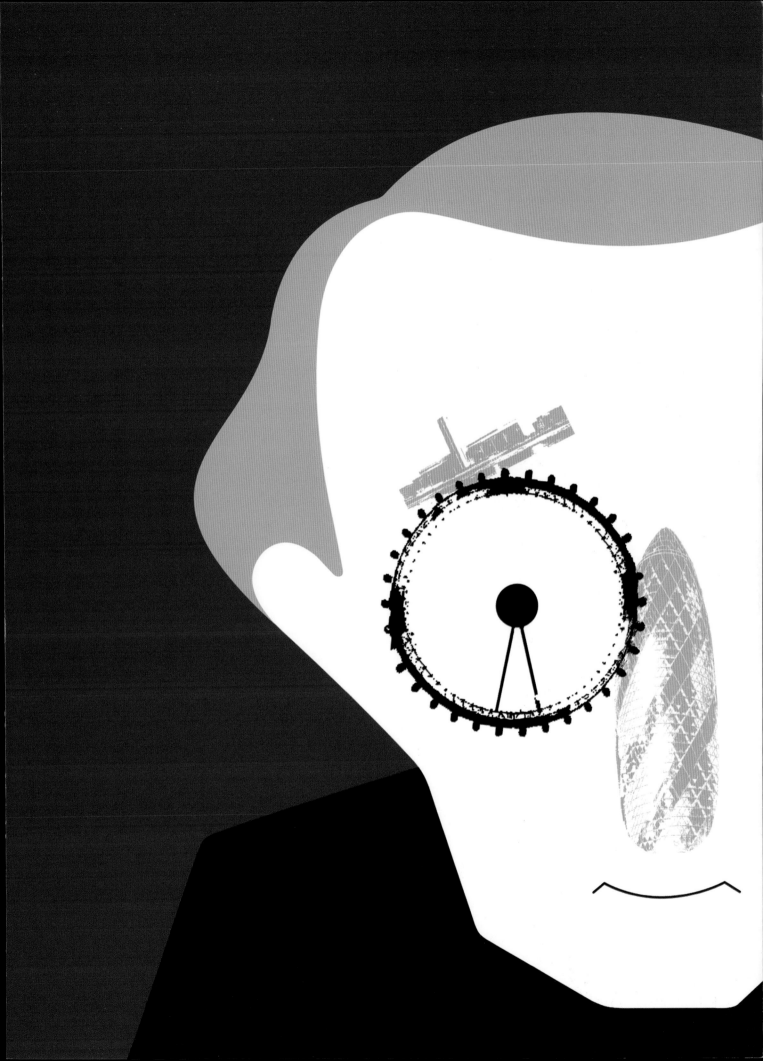

**STEVEN
SPIELBERG**

Q
What aspects of the culture and politics most
stimulate your work?

A
What stimulates me is the story, the crucial ideas
and how they play into the subject's facial struc-
ture. Whatever the person represents, if the face
is iconic, it makes my work effortless.

Spike Lee always wears a hat, and he is no stranger to film. It makes sense that Bar chose to use bits of celluloid to suss out Lee's face. While it may seem like Bar often goes for the obvious, he does pay great attention to detail. In this case, he uses the fact that the end of a roll of film is cut in a way that approximates the bill of a baseball cap.

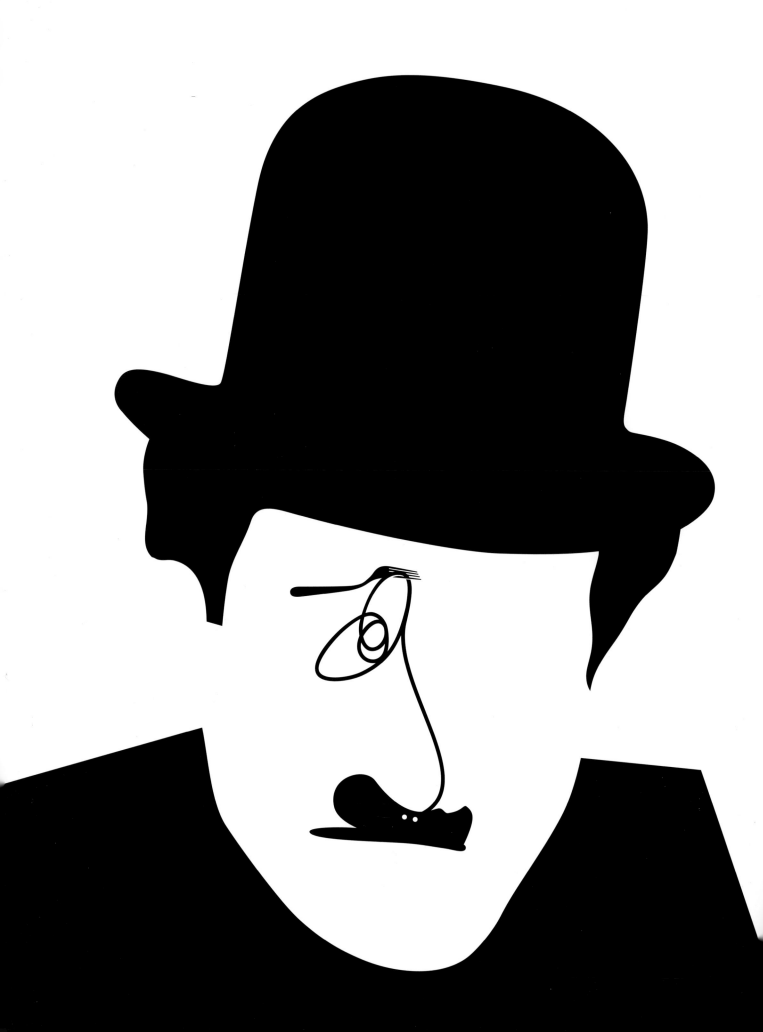

When Bar works with black and white, he relies on negative space to "create forms that allow elements to float." Here, Bar uses one of Charlie Chaplin's most famous on-screen moments to define his face, though there are few actual lines. Inspired by Chaplin's shoe-eating scene in *The Gold Rush*, Bar turns a shoelace sum spaghetti strand into Chaplin's eye and nose; the shoe works double duty as both moustache and mouth.

As Bar started work on Bill Murray, he was
pleased to discover that in profile, Murray's face
created a ghoulish figure in the negative space.
The *Ghostbusters* icon for an eye is a rather
obvious, but effective choice.

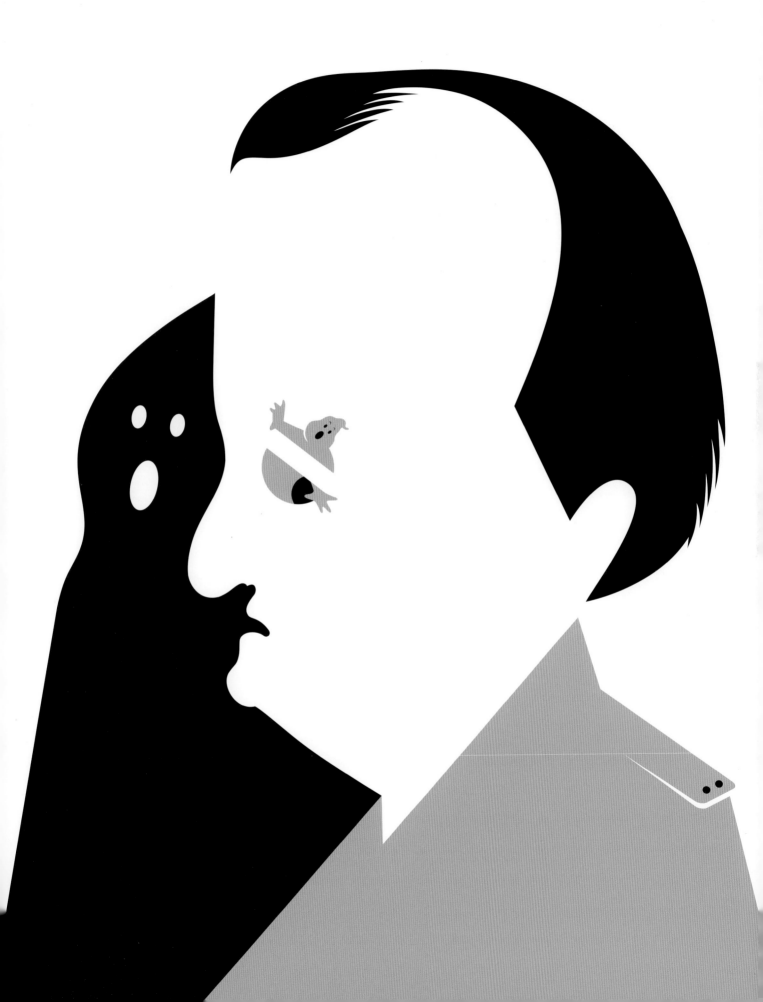

**DAVID
CROSS**

Funny man extrodanaire David Cross appeared on the popular television sitcom *Arrested Development* as Tobias Funke, the world's first "analrapist," a combination of an analyst and therapist. More recently, Funke has endeavored an acting career, though he will never get a role that requires nudity because he suffers from the "nevernude" affliction. As the name suggests, Funke can never allow himself to be totally nude, so he showers in tight cut-off jeans, which just so happen to make for an excellent moustache.

When Bar speaks of this "spooky" face, inspired by "featureless Manga faces" there is a devilish lilt to his voice. Joan Rivers has made a career out of accosting celebrities and being the butt of plastic surgery jokes. Bar's favorite part of this portrait are the scalpels, especially the one cutting into the lips, which gives the impression that her teeth are black. "Her lips are so inflated," Bar says, "that her teeth just seem to pop out."

**KEVIN
BACON**

Forget about *Foot Loose* and *Apollo 13*, Kevin Bacon's biggest claim to fame is Six Degrees of Kevin Bacon, the pop-culture theory devised by two students at Albright College in Reading, Pennsylvania. The concept hinges on the idea that through Kevin Bacon's numerous roles, the whole of Hollywood can be reached. If Bacon hasn't worked with someone, he has worked with someone who has worked with that person. It is argued that you can get to any actor, dead or alive, in less than six jumps. The arrows that comprise Bacon's face here indicate the motions of the theory. Go ahead, give it a try...

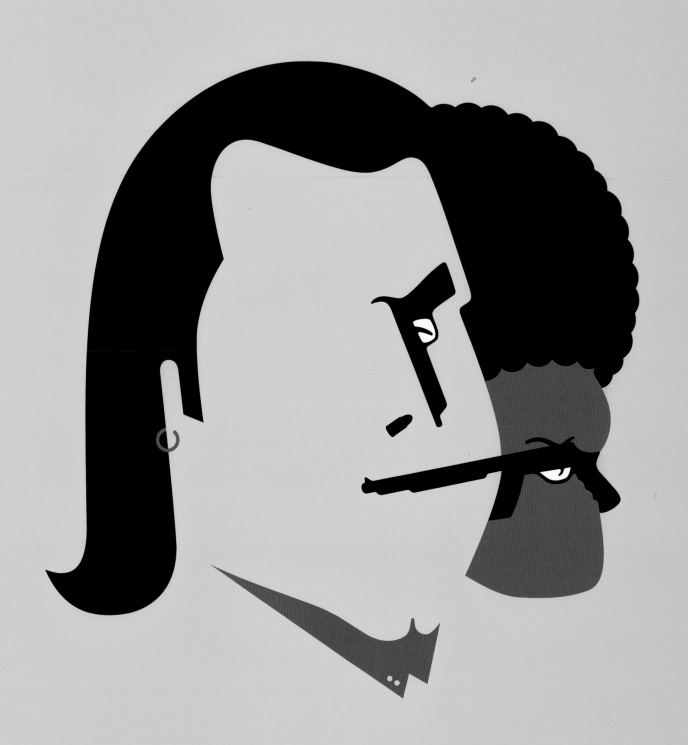

JOHN TRAVOLTA
SAMUEL L. JACKSON

Two faces may not be better than one, but they are harder to draw. Illustrating a duo like these two *Pulp Fiction* characters is a challenge for Bar because he still needs to render them as a single, connected unit. Clearly, in this example, Bar conjoins the two with the gun: Travolta's mouth, Jackson's eyebrow and nose.

SYLVESTER
STALLONE

Commissioned for UKTV, this portrait speaks for itself. No really, when you look at this, don't you hear a slurred "Adddrrrian"? The boxing gloves, while used as replacements for Sylvester Stallone's mouth and eye, also instill a sense of movement. Rocky on the receiving end of a one-two punch.

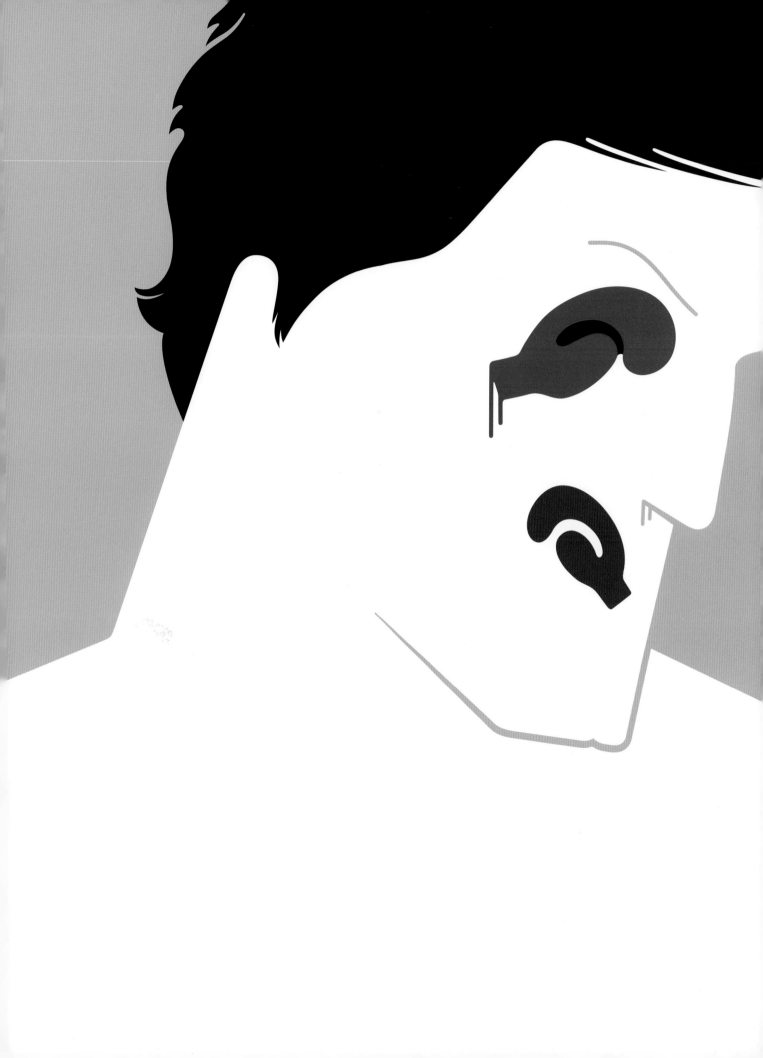

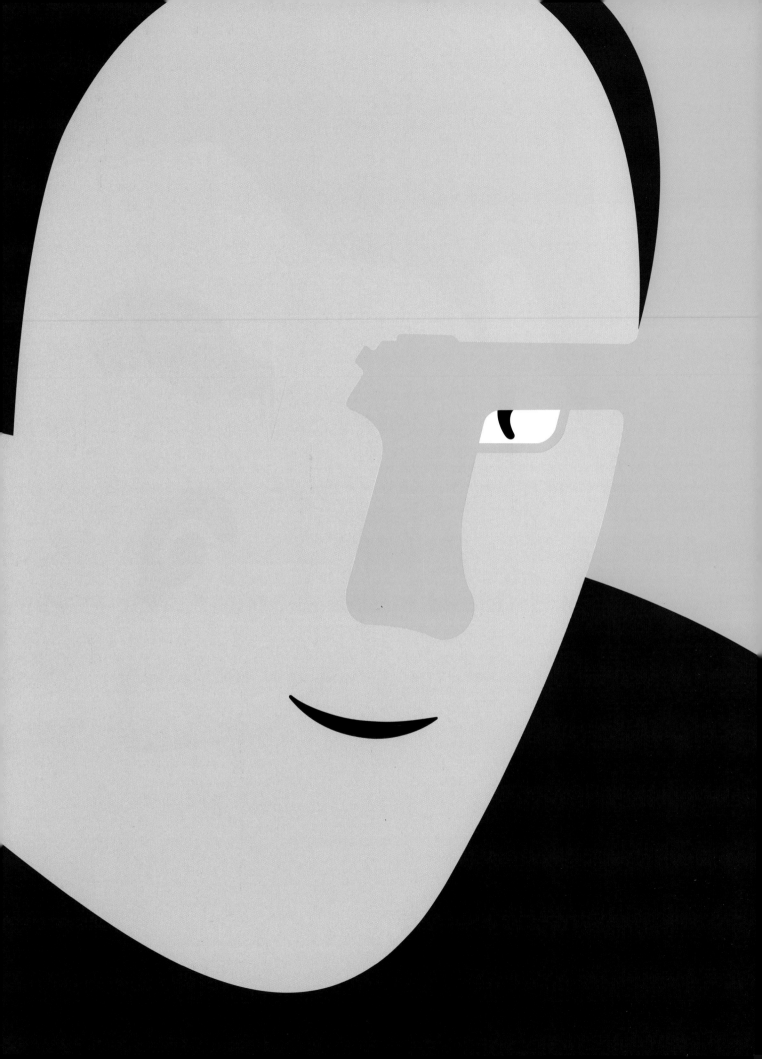

Bar encapsulates the most salient aspects of a personality through the visual. In the case of actors, it is almost as if they become tattooed by their roles. Few people remember James Gandolfini's roles outside the Tony Soprano character. An image like this one proves the power of association, however, because even with hardly any facial features, there is Tony Soprano staring you down!

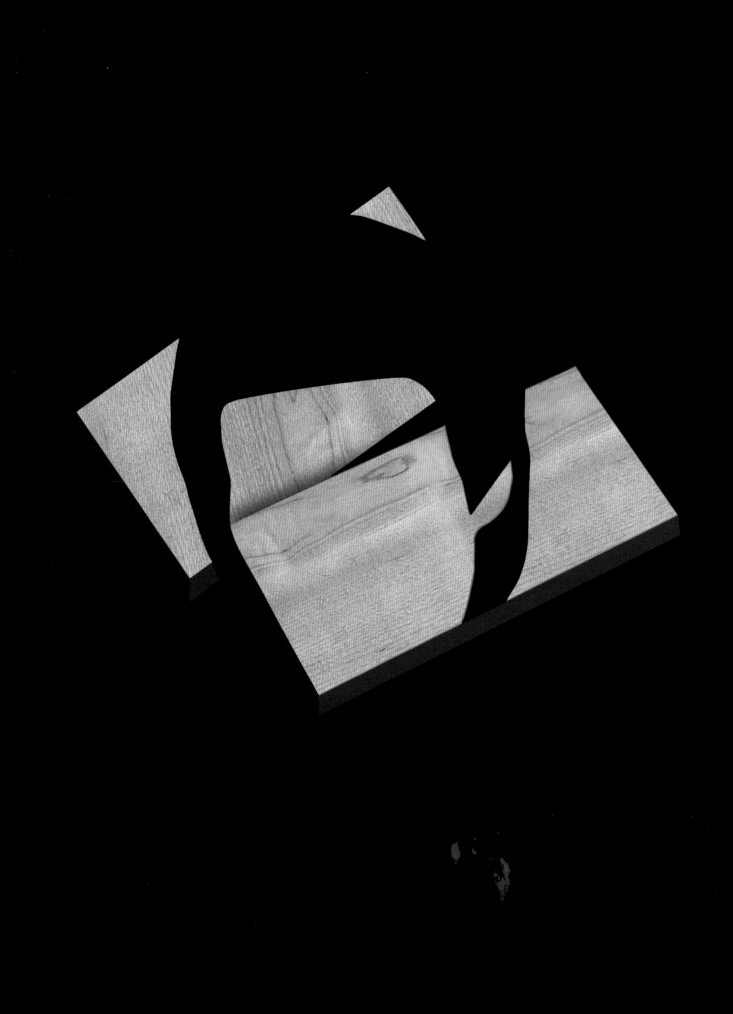

**BRUCE
LEE**

An unusual sample from Bar's repertoire. Black dominates this illustration, but it is the split plank of wood that evokes Bruce Lee. A distinctive head of hair and the ability to chop things in half make this a recognizable portrait.

POLITICAL
FIGURES

GEORGE W. BUSH

One of the more striking images in this book, this portrait relies on one of the more striking images of the Iraq war to achieve its effect. While Bar concedes that, "he cheated a little to get the nostrils," by altering the prisoner's gown, he is proud of this illustration. The wires limn Bush's face and hairline, while the prisoner becomes the focal point of the President's administration. It is an indictment of Bush, placing responsibility for the war squarely on the Commander in Chief.

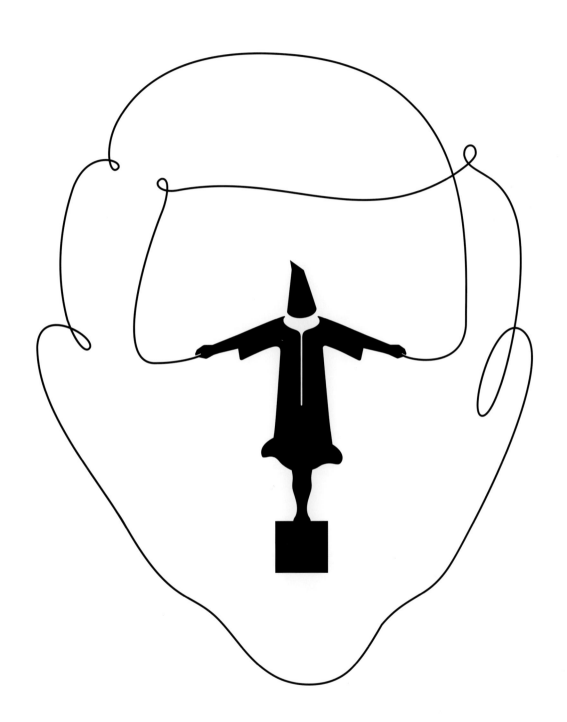

SADDAM
HUSSEIN

Bar lives in London, but he is from Israel. This series of Saddam Hussein images spans Bar's career as an illustrator. The image that uses the radioactive symbol for Hussein's face comes from one of Bar's earliest sketches, done while holing up in an air-raid bunker during the first Gulf War. The *Guardian*, in the UK, commissioned the image of the scales of justice spilling over with blood. It demonstrates the bloody consequences of Hussein's trial, which of course elicited scores of assassinations and bombings. Finally, the sequence comes full circle in Bar's response to Hussein's controversial hanging. The beret atop Hussein's head in the first illustration becomes his moustache, which is dominated by the noose.

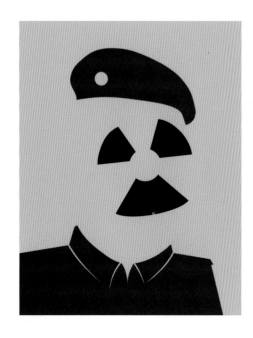
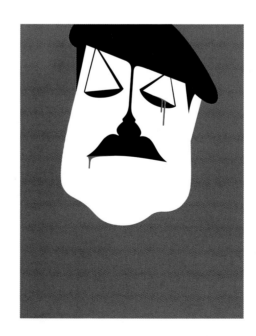

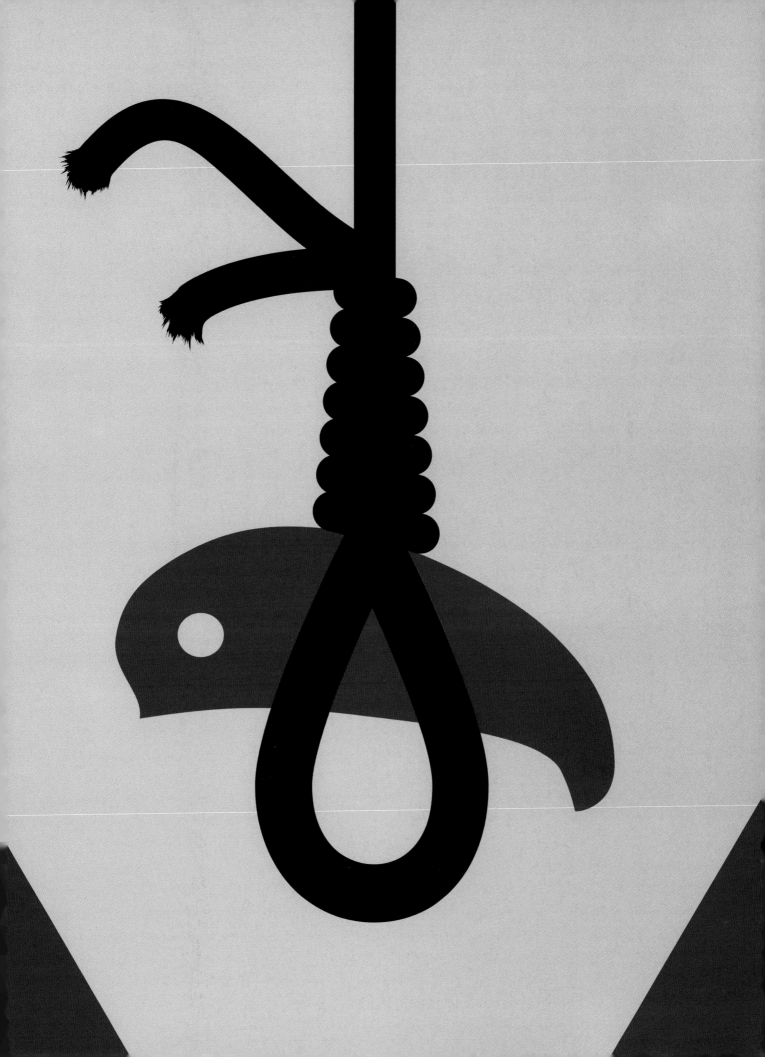

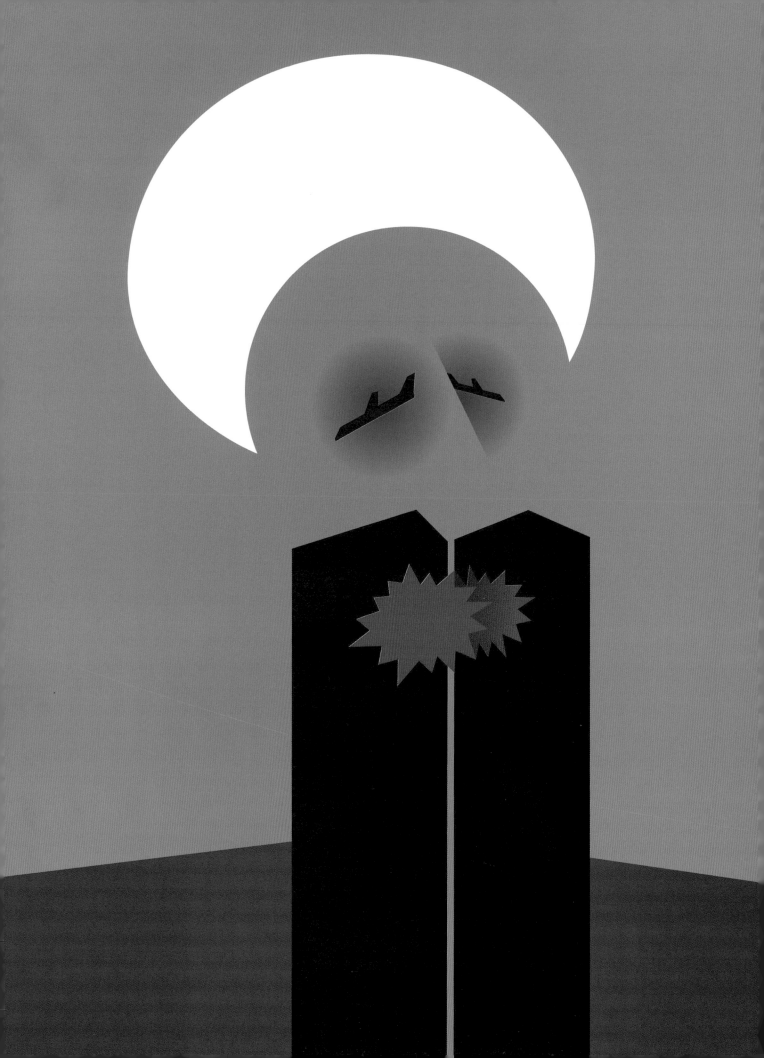

This image boldly speaks for itself and, more
than many of Bar's illustrations, demonstrates the
associative power of the visual. Not much about
this looks like the actual Osama Bin Laden, but the
exploding towers and airplanes for eyes make
clear Bar's intention with this piece. This was not
a commissioned work, and Bar is quick to admit
that most editors and art directors would not
allow him such expressive freedom.

Known the world over for his cavalier rhetoric about North Korea's nuclear capability, missile contrails make for the glasses of Kim Jong-Il. Commissioned by the *Guardian*, Bar was under deadline, and to this day when he looks at this illustration, he wishes he had had the time to use only one missile. Be that as it may, this illustration works, as it looks like Kim and also incorporates what he is known for, weaponry and antagonizing the United States.

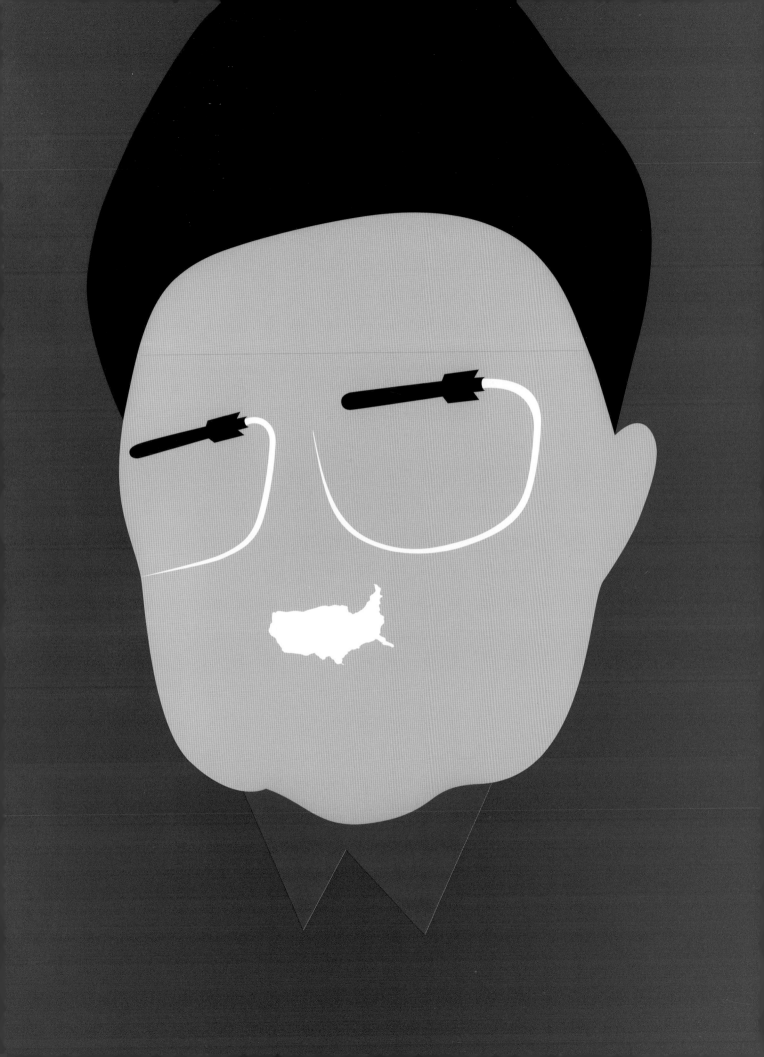

When the *Guardian* ran a piece that examined
Australian folk-hero Ned Kelly, Bar incorporated
imagery made iconic by Kelly and his gang
for the commission. Involved with a number of
confrontations with authorities over theft and
murder, the Kelly Gang became the symbol of
Australian defiance of its colonial rule. During the
Kelly Gang's last stand, which resulted in Kelly
being hanged, he and his crew wore hand-craft-
ed armor in an attempt to outlast the police. The
armor was of no help in the end, but it helped
secure Kelly's legacy.

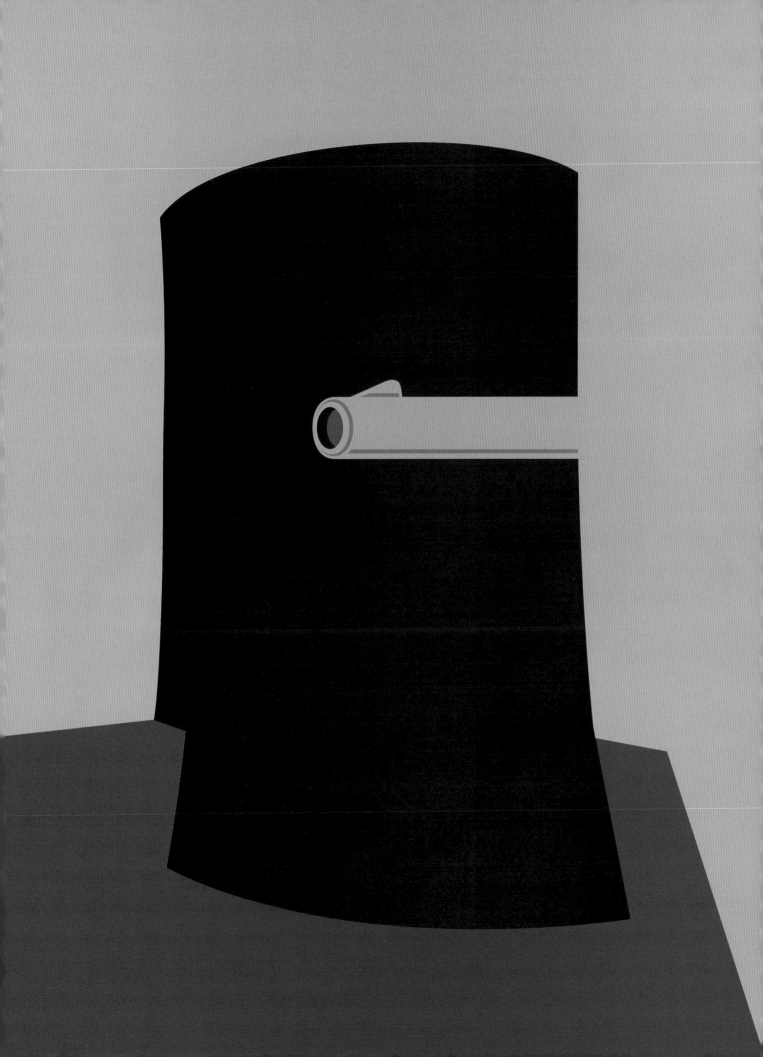

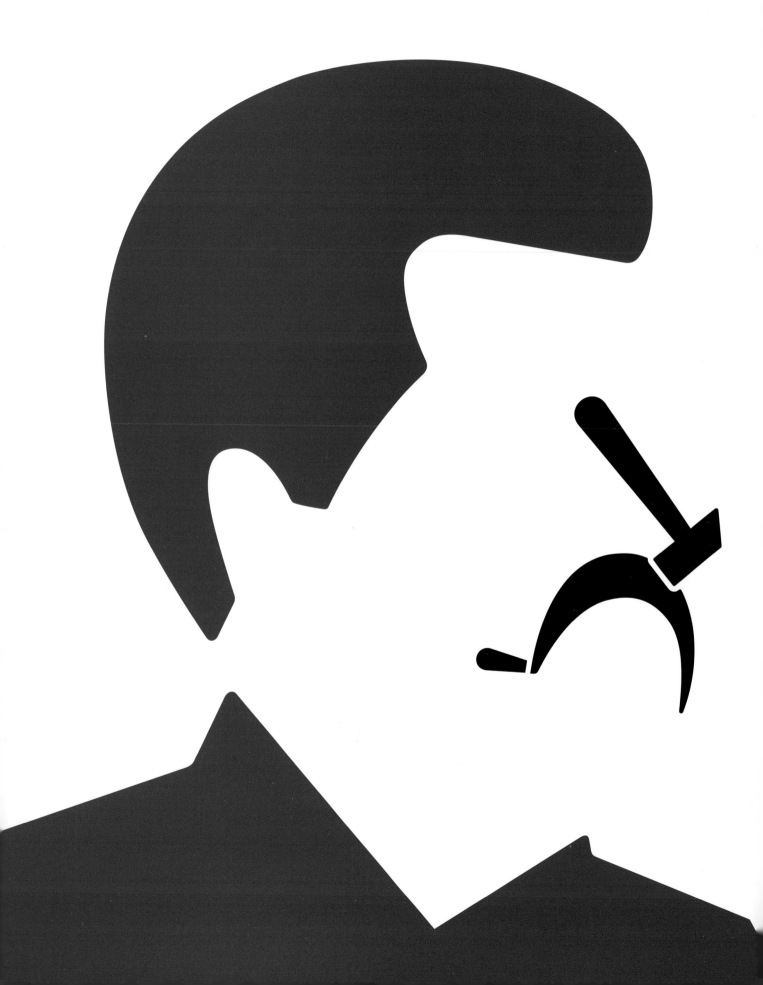

The hammer and sickle get rearranged into
Joseph Stalin's nose and mouth. That these two
icons can be taken out of context, but remain
in context in that they possess such associative
power that a viewer will know who this feature-
less face is, bolsters the effectiveness of Bar's
approach to illustration.

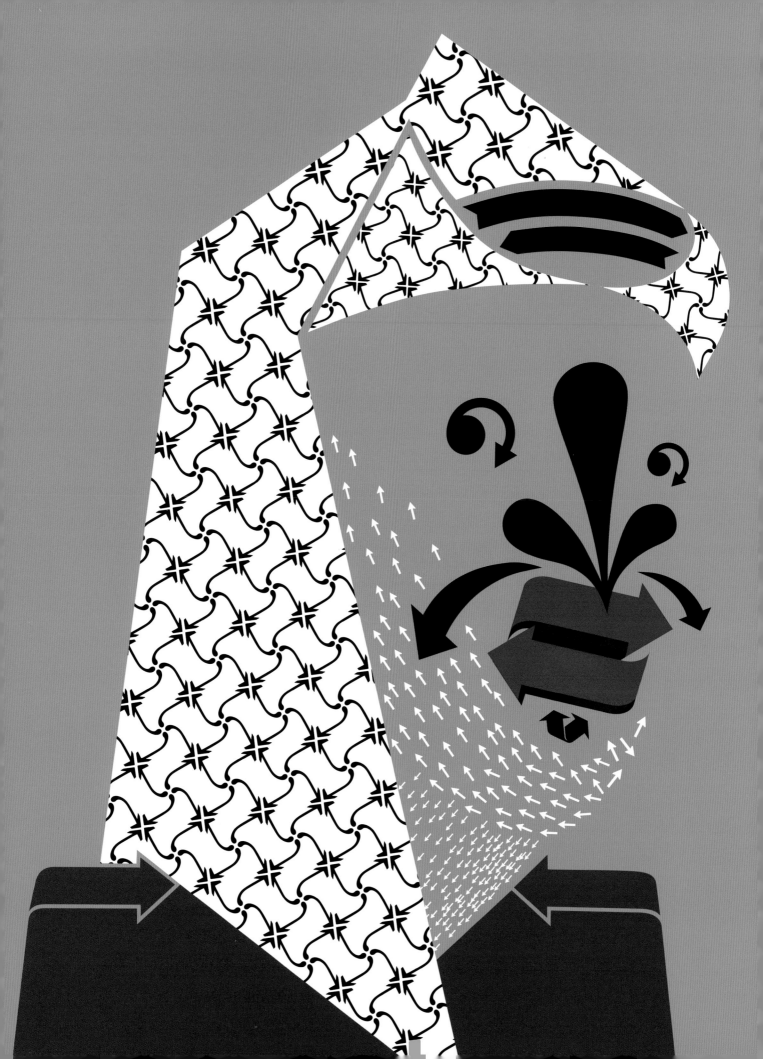

Having grown up in Israel, Bar is no stranger to the conflict that plagues the region. Bearded with arrows, this portrait of the former chairman of the Palestinian National Authority reflects Bar's analysis of Yassar Arafat's leadership. A consummate politician, Arafat "promised to go in everyone's direction."

This portrait of Hitler accompanied James Delingpole's article "Mein Kash: Milking the Third Reich," written for *Esquire UK*. The piece examined the publishing trend to release books about Hitler (which number close to 1,000 on Amazon). For such an article, Bar's choice to convert the moustache into a barcode was spot-on.

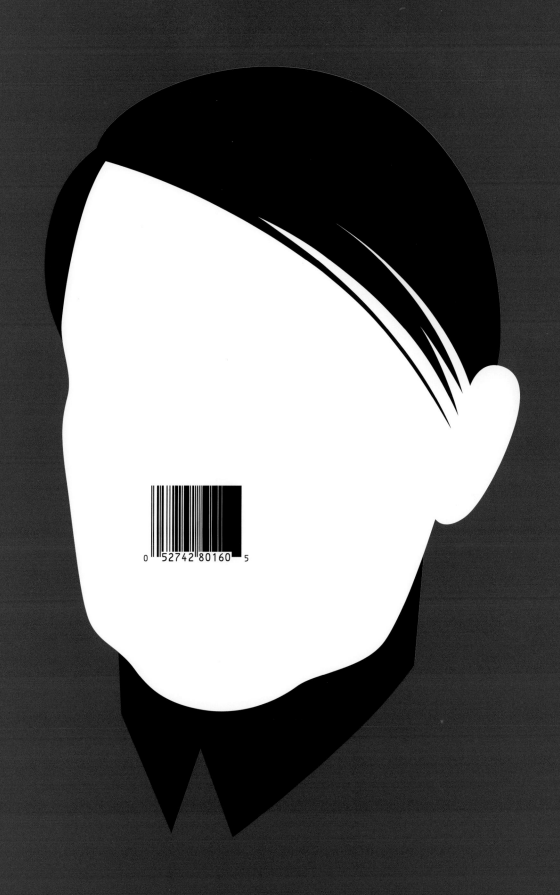

MARGARET
THATCHER

The smoking torch that defines Margaret
Thatcher's face in this illustration remarks on
the fading political power of her Conservative
Party, descended from the Tory Party. Equally
adored and maligned as England's Prime
Minister from 1975 until 1990, the end of her tenure
was spurred by internal struggle within the party.
In assessing her legacy, Bar appropriated the
old Tory logo to give a visual representation of
flagging power. The old Tory logo was a
flaming torch, while Bar's interpretation smolders.

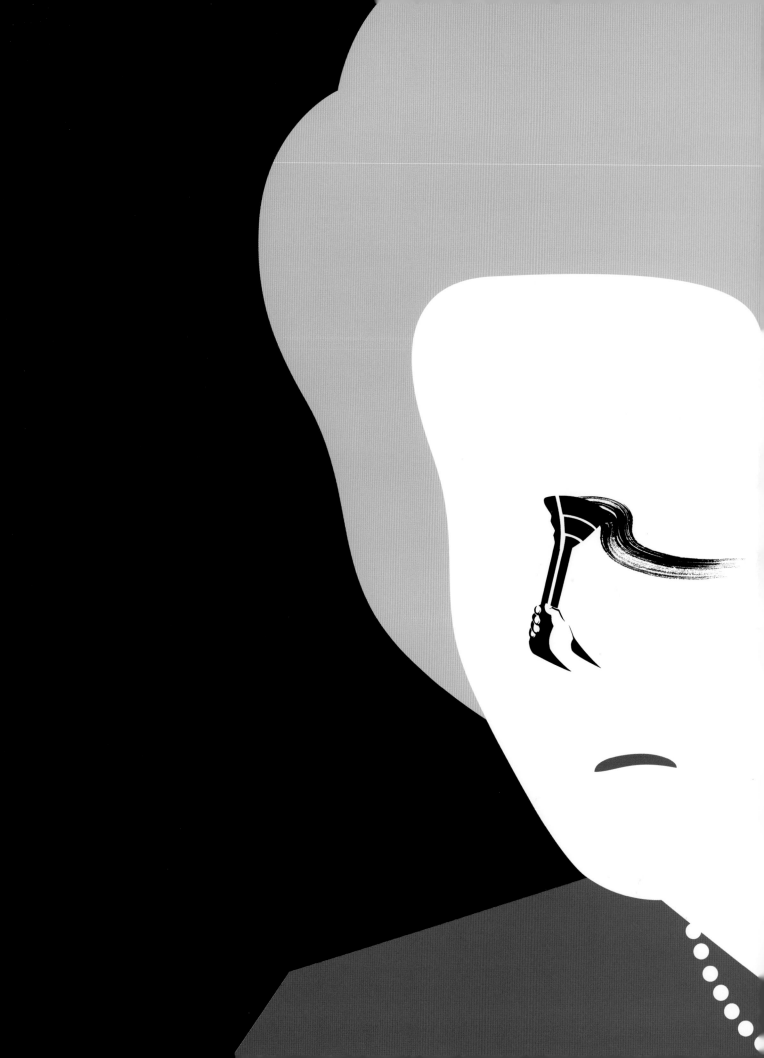

**VLADIMIR
PUTIN**

This illustration is a response to the events
surrounding the death of former KGB spy
Alexander Litvinenko. Poisoned with the radio-
active isotope polonium-210, Litvinenko had
been critical of Russian policies. On his deathbed,
Litvinenko named Russian President Vladimir Putin
as being linked to the events. Putin denied the
accusation vehemently. Using parts of the
pictogram for corrosive materials, Bar renders
Putin's face, making for a suggestive illustration.

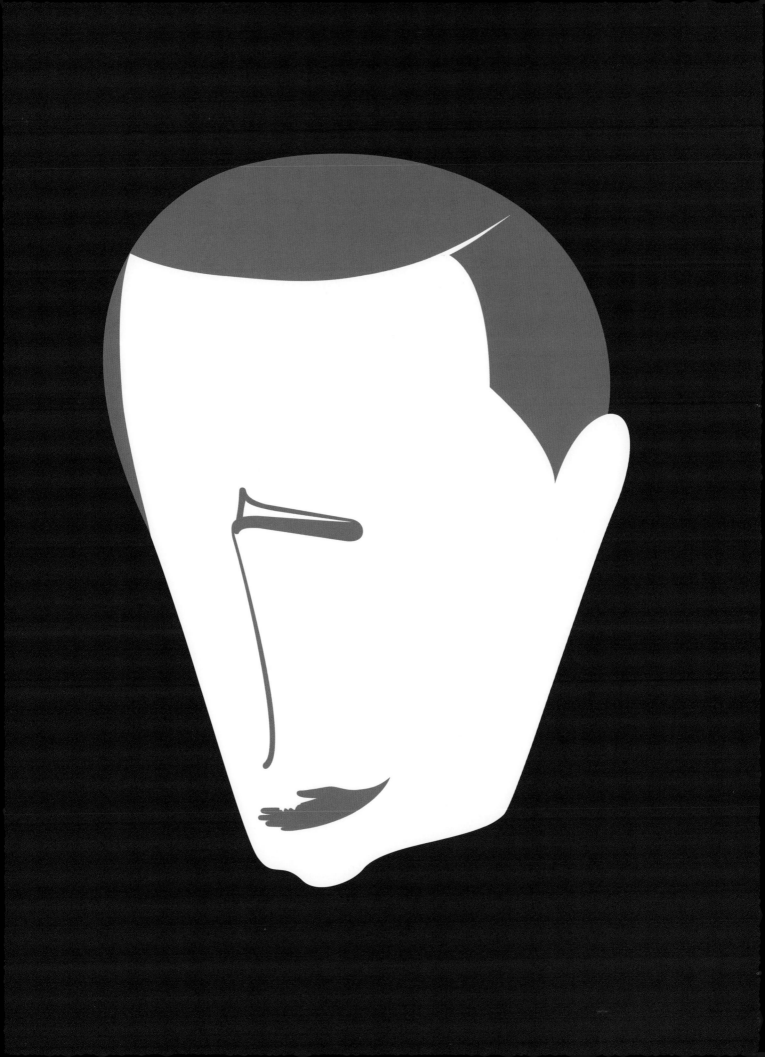

NELSON
MANDELA

Many of Bar's subjects become his subjects
because of dubious behavior. Nelson Mandela's
anti-apartheid activism, however, is a story of
incredible strength in the face of imprisonment
and injustice that concluded with triumph.
Mandela was South Africa's first president to
be voted into office in a representative demo-
cratic election. Mandela figuratively broke the
shackles that imprisoned him for 27 years, and
it is this strength that Bar celebrates with this
illustration.

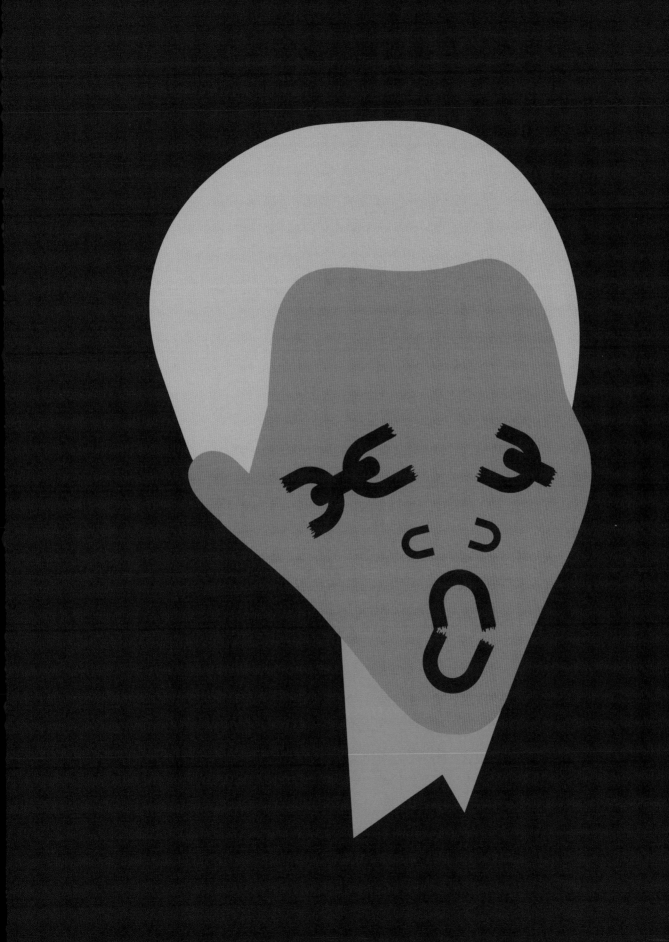

BRITPOP
STARS

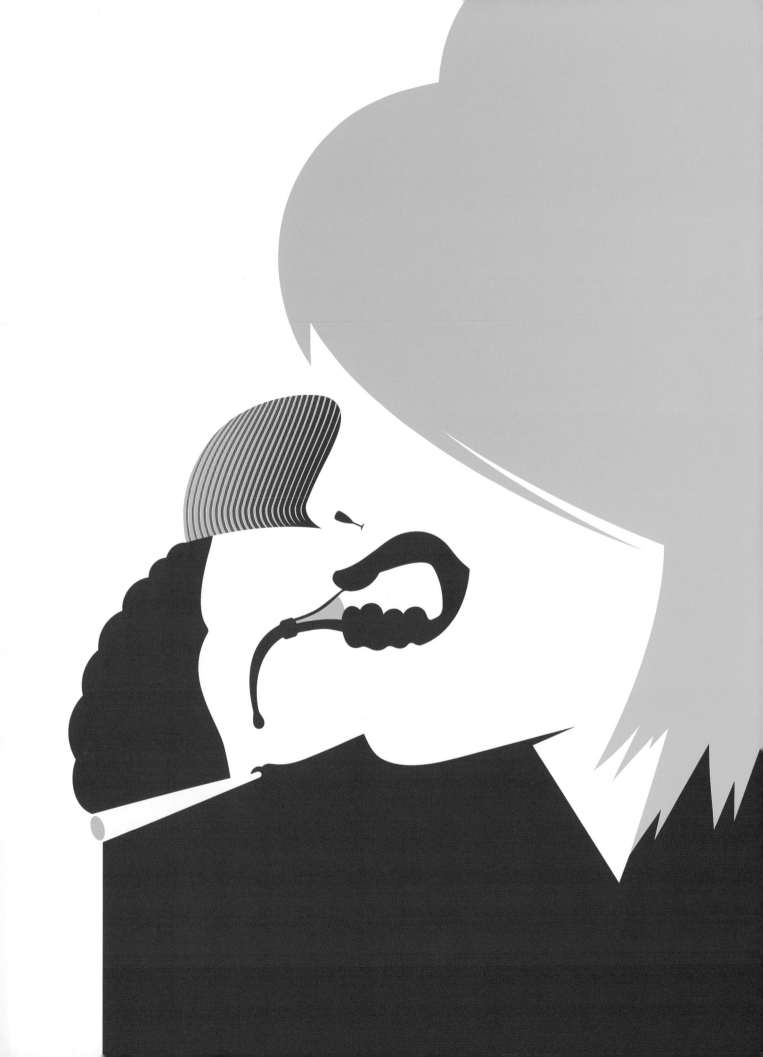

The two women known as Ab Fab, from the cult
hit BBC comedy *Absolutely Fabulous*, for better
or worse, represent what Bar calls "champagne
culture." Their hedonistic ways manifest in sex,
drugs and booze. Bar intergrates the two of
them into a single illustration through the images
of a bottle and a spliff. In doing so, he says a lot
about the characters, and also gives himself lines
to create a unified illustration.

JAMIE
OLIVER

Celebrity chef Jamie Oliver has probably spent
as much time on TV and book tours as in the
kitchen. An advocate of simple, healthy home
cooking, a mortar for a mouth and a pestle for a
nose make this face recognizable.

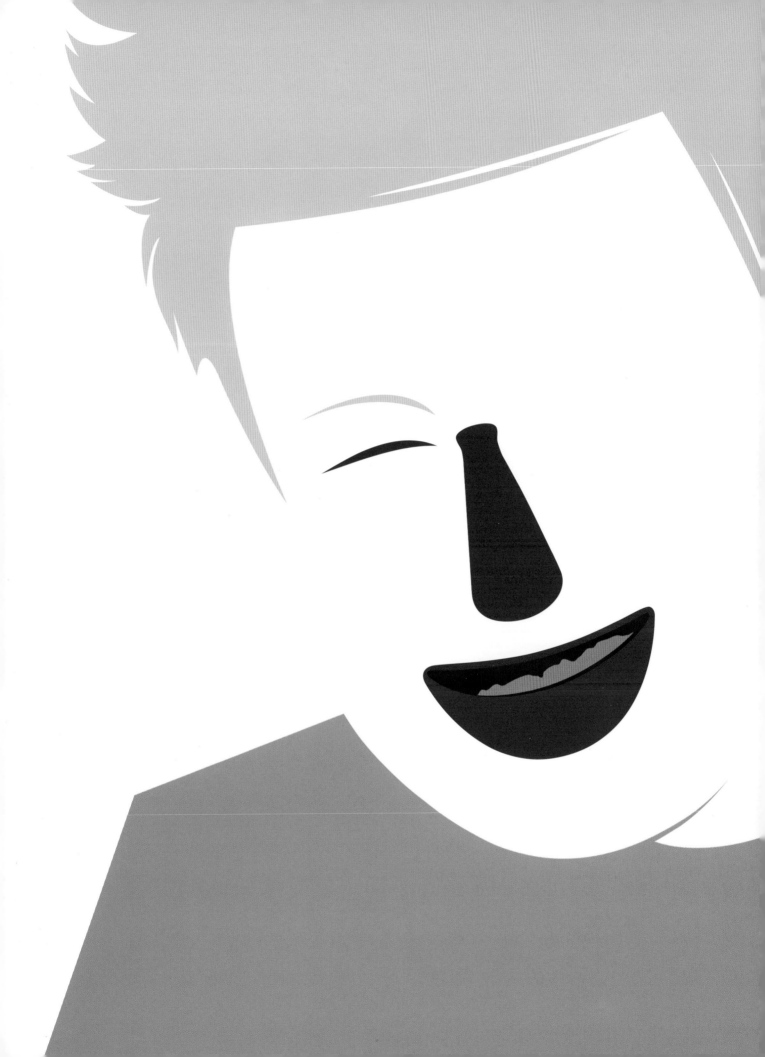

JOHN
CLEESE

One of John Cleese's most memorable charac-
ters is the walking comedy of errors that was
Basil Fawlty, from the BBC's *Fawlty Towers*.
Imasculated by his wife, misunderstood by his
employees and a mystery to his guests, this
hotelier's mishaps have made millions laugh.
Cleese's distinctive countenance coupled with
the front desk bell that insured comedic drama
for the character make for an iconic
image that is far from sarcastic.

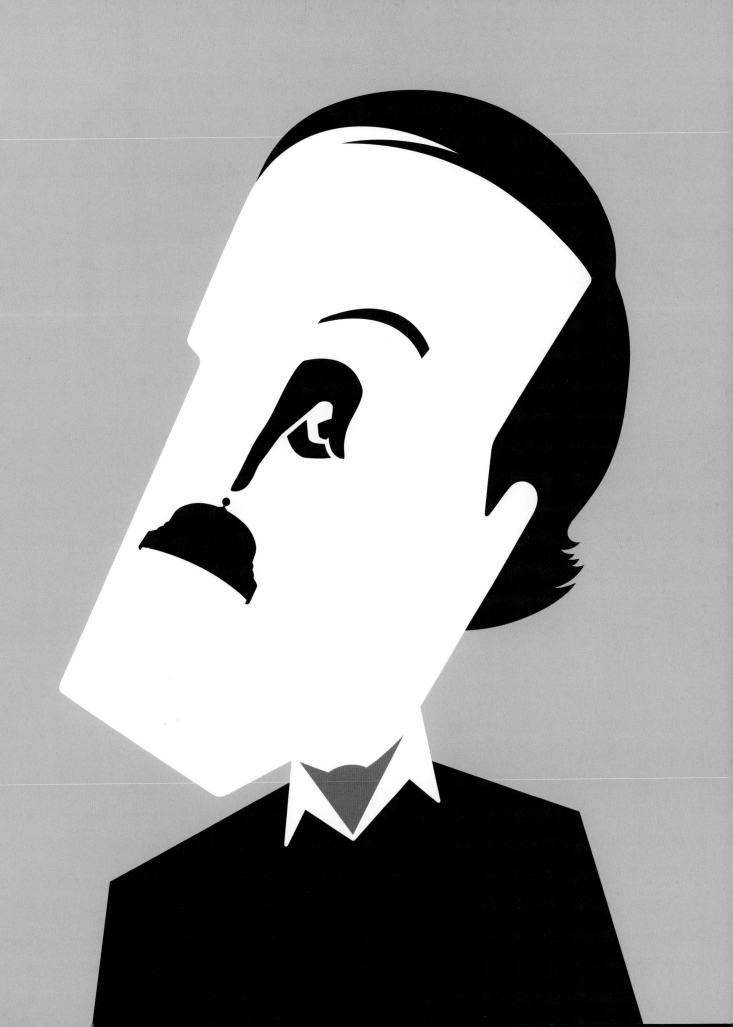

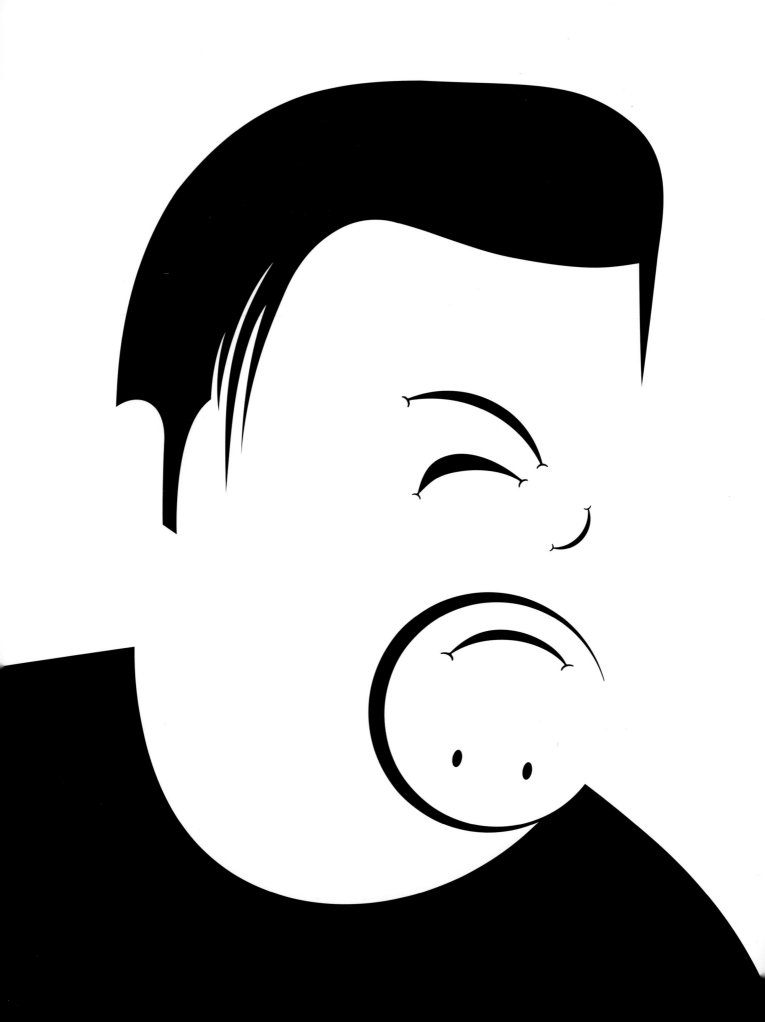

Through his roles in shows like *The Office* and *Extras*, Ricky Gervais, for Bar, embodies the black humor of "loser culture." Using smiley faces in a truly ironic fashion, Bar provides a portrait of a "contemporary, classic sad clown."

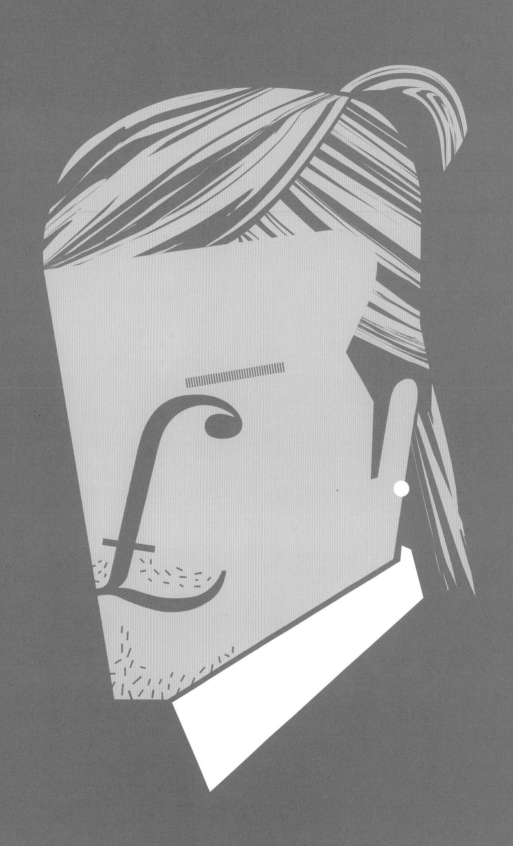

**DAVID
BECKHAM**

These days, the dollar sign would be just as appropriate for David Beckham's face as the British pound symbol. The soccer star and money-making machine that is Beckham now spans across the Atlantic Ocean, all of the way to Los Angeles. We'll see if one man can make Americans soccer fans, but even if he can't, he'll still be rich.

JEREMY
CLARKSON

Watched by hundreds of millions of people all
over the world as host of the BBC 2 show *Top
Gear*, Jeremy Clarkson is famous for talking
about cars, and his deadpan provocation,
which lashes out at car manufacturers as well as
Americans. His kink-curled hair easily becomes
a nest of automobile tires. The gear shift box fits
nicely on his angular face.

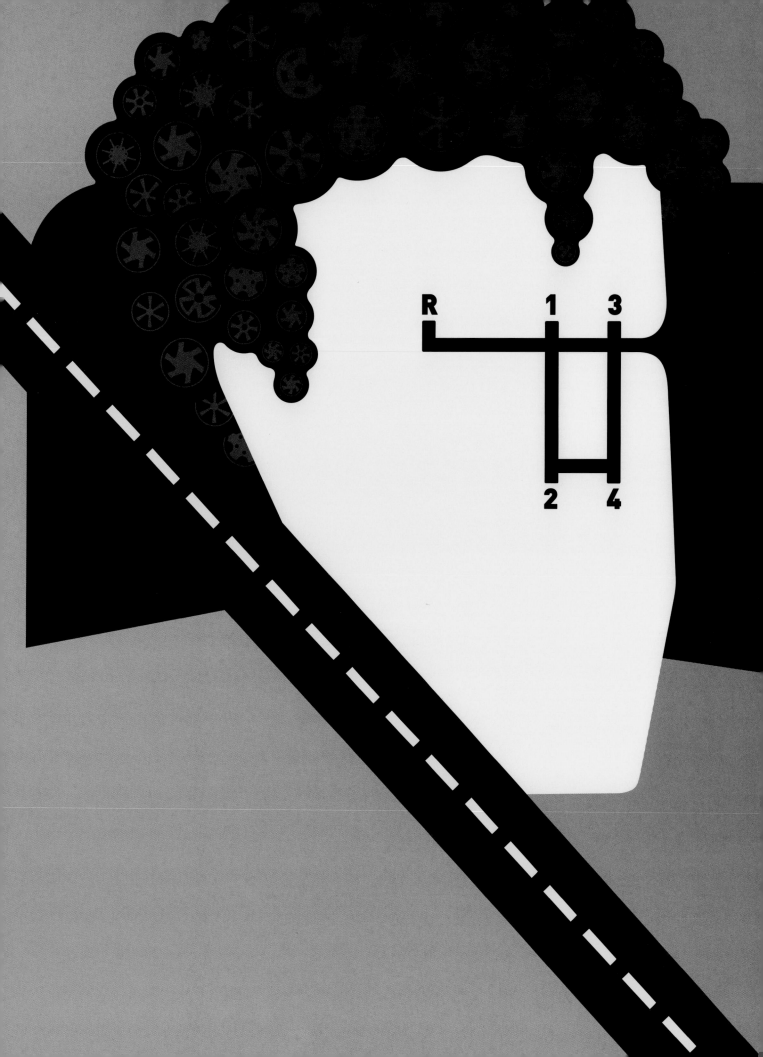

**MATT LUCAS
DAVID WALLIAMS**

Stars of the randy British sketch-comedy show
Little Britain.

Q
Is there a person that you have never been able
to get just right?

A
People with balanced faces and people that
haven't lived very public lives are harder for me
to solve but I don't think that I've had someone
that I couldn't get right in the end, though these
projects may take me longer. Another challenge
is when I have to merge two characters into one
piece because I need to fit two faces into one
unified concept.

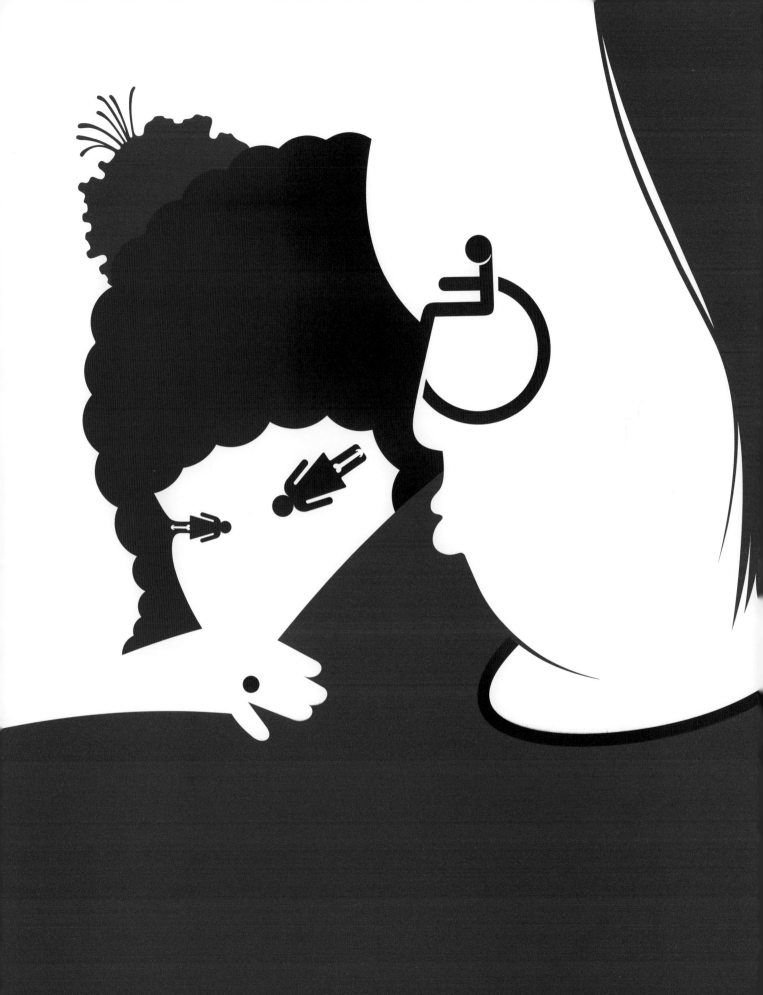

NAOMI
CAMPBELL

Q

You don't shy away from controversial subject matter. Do your editors ever ask you to tone it down? If so, what kind of images have they had bad reactions to in the past?

A

Quite often my works are sent from the graphic department to the legal department at editorial magazines. One time, I was asked to remove the image of cocaine from Naomi Campbell's face. (The story was about *Daily Mirror* photos that showed Campbell leaving a rehab clinic.)

CHRIS
EUBANK

Bar counts this illustration among his favorites because it follows the actual shape of this former boxer's head. From being a WBO Super-Middleweight and Middleweight title holder, to filing for bankruptcy, to being voted the second most eccentric celebrity next to Bjork, to being arrested in early 2007 for driving through London with a banner that read, "BLAIR - Don't send our young prince to your catastrophic illegal war, to make it look plausible!" Chris Eubank is a true personality. Perhaps that's why Bar went for a simplistic approach, utilizing Eubank's flat head, and nothing more than a pair of boxing gloves.

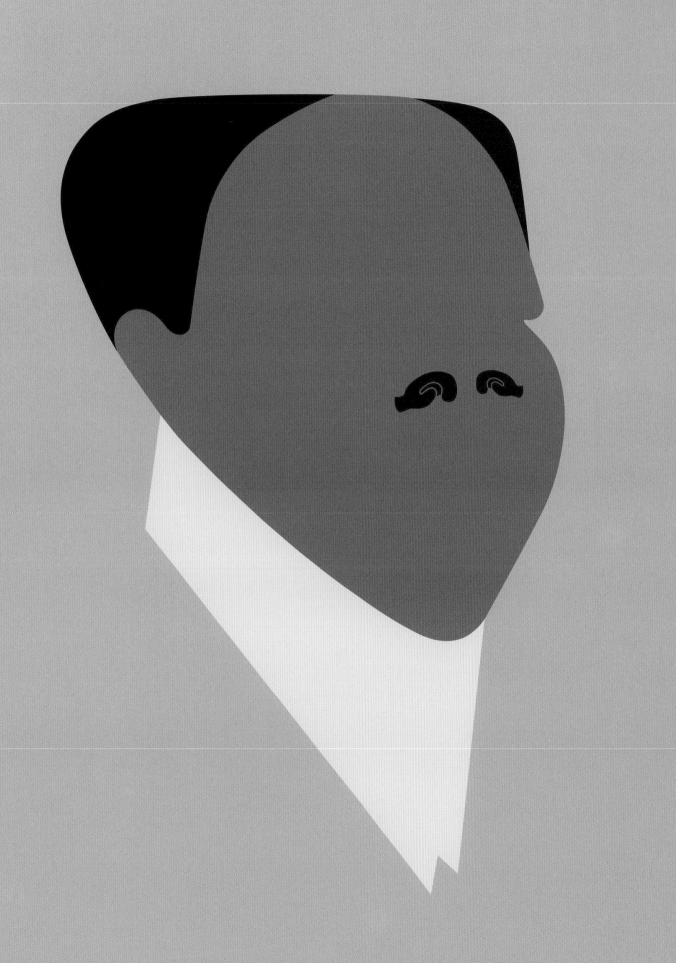

THE
MUSICIANS

**BOB
DYLAN**

A true cultural icon, Bob Dylan is no stranger to
being interpreted. Bar keeps this one simple,
using three of Dylan's tools of the trade: musical
notations, guitar, harmonica. That Bar can invest
such age and mystery into a face that is primarily
white negative space is yet another example
of his ability to see subjects as more than just
people – they are their careers.

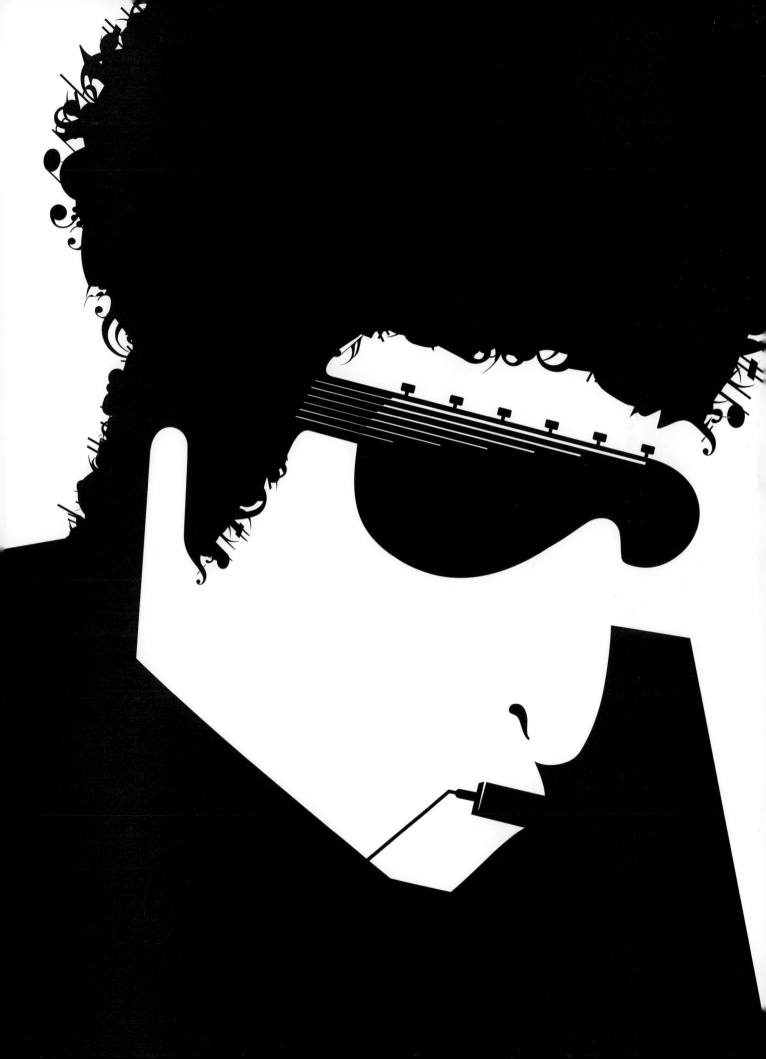

BRITNEY SPEARS
KEVIN FEDERLINE

Although Bar finds it more challenging to gel two faces into one image, this one of Britney Spears and Kevin Federline is a satirical masterpiece, even in light of the couple's split, and Britney's shaved head. The dancer, turned husband, turned father of Britney's two children, turned divorcee, turned rapper, is often mocked by the media for milking a lackluster public persona out of his former wife's stardom. Bar's decision to make Spears's eye into a pacifier plays on the fact that he is the father of her children at the same time it suggests that Federline is as dependent on Spears as newborns are on their mothers.

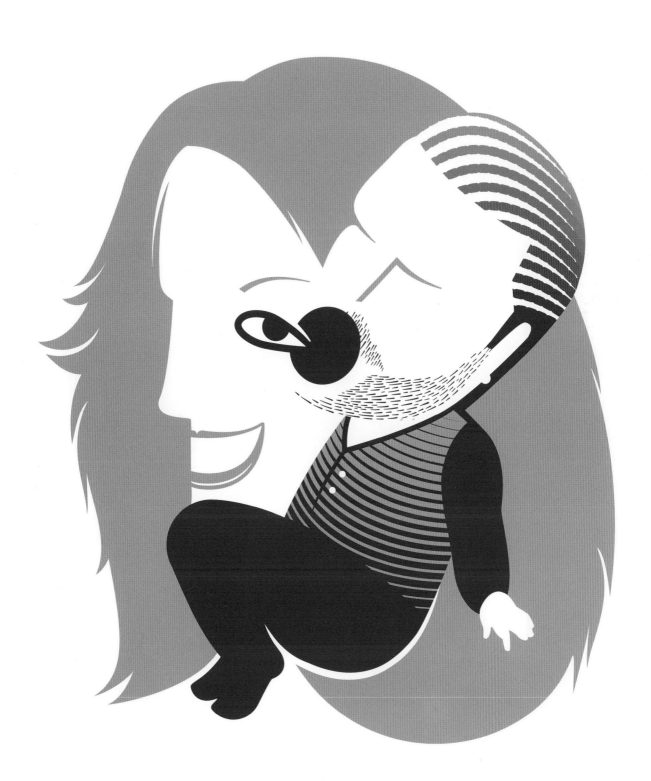

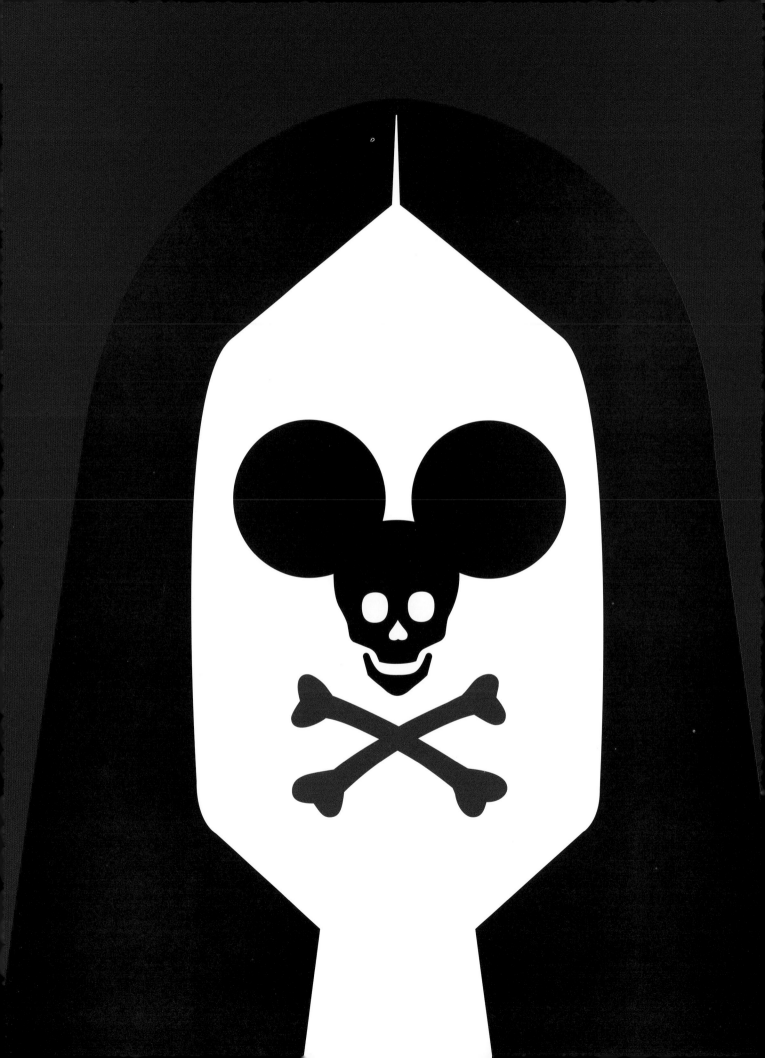

The commentary here deals with the conversion of Ozzy Osbourne from bat-biting rebel to a mainstream, joking entertainer. Taking salient visual aspects of the skull and crossbones poison symbol and Mickey Mouse, Bar creates what he refers to gleefully as the "Mickey Mouse of death."

Q

What kind of research do you do as you prepare to draw a personality?

A

I tell stories through faces. Sometimes, the story is assigned, other times, I choose the story because I think it's relevant. Regardless, I research my subjects through texts, looking for iconic events or elements from their lives, looking at films and any other relevant media to reach a full understanding of how they look, talk, smile, etc. My aim is to capture the subject's most iconic expression.

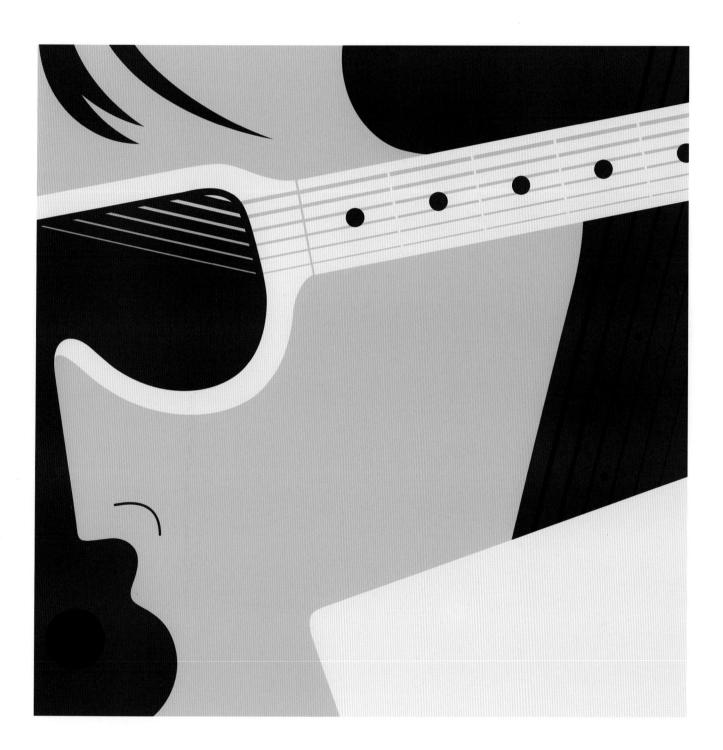

JOHN LENNON
YOKO ONO

In the wake of their marriage in 1969, John Lennon and Yoko Ono used their notoriety to protest the Vietnam War. Staging two week-long "bed-ins" that year, one in Amsterdam and the other in Montreal, the two generated media attention by doing little else than spending a week in bed. The event was so well publicized that it is easy to recognize it in Bar's minimalist illustration.

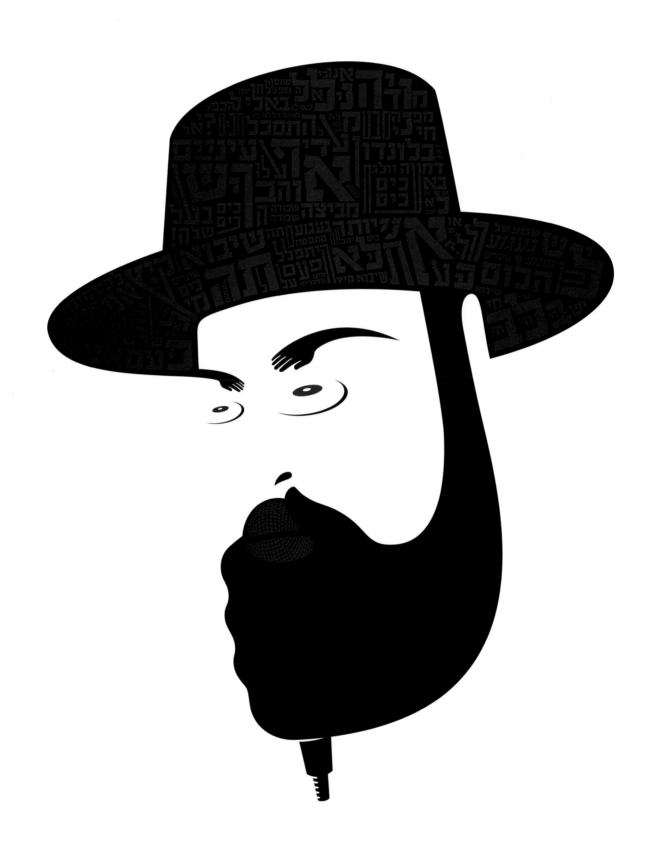

The world's most famous performer of American Jewish Reggae, Matisyahu writes songs inspired by the teachings of Judaism. He wears the traditional garb of Hasidic Jews and does not perform on the Sabbath. Bar works Hebrew into the hat, and a microphone into his beard and mouth.

THE
BLUES
BROTHERS

This commission accompanied an article about the rise in popularity of "movieoke," a form of karaoke where participants mimic their favorite movie scenes instead of their favorite songs. Apparently, *The Blues Brothers* is among one of the most popular movies for people to ape. It makes sense since the film contains plenty of rocking musical numbers from the likes of Aretha Franklin, Ray Charles and James Brown, not to mention Dan Akroyd and John Belushi. The Blues Brothers uniform of a cheap black suit, black hat and shades makes this duo recognizable in this illustration. The microphones reference the movie, the movieoke craze and stand in for sunglasses.

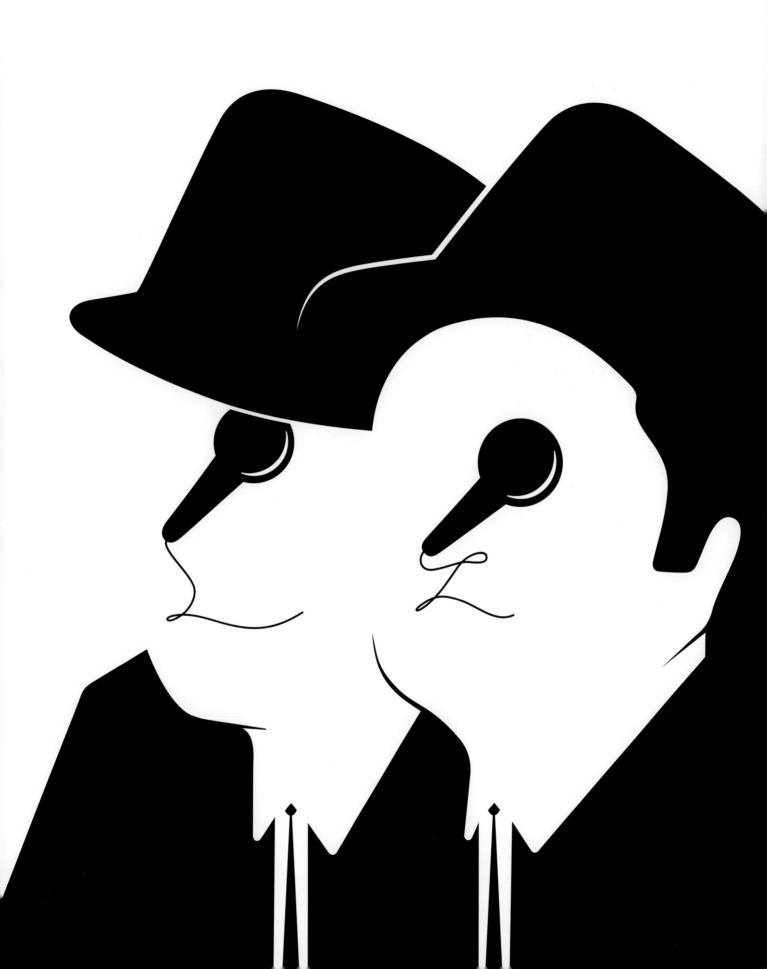

**PETE
DOHERTY**

The lead singer for the UK band Babyshambles is much better known for his relationship with supermodel Kate Moss, the short-lived success of the Libertines and his drug habit. With a lone cigarette dangling, a pill for an eye and a needle eyebrow, Bar focuses this portrait on the most public aspect of Doherty's life – his battles with addiction – which are well documented in court hearings that have resulted from various arrests and altercations.

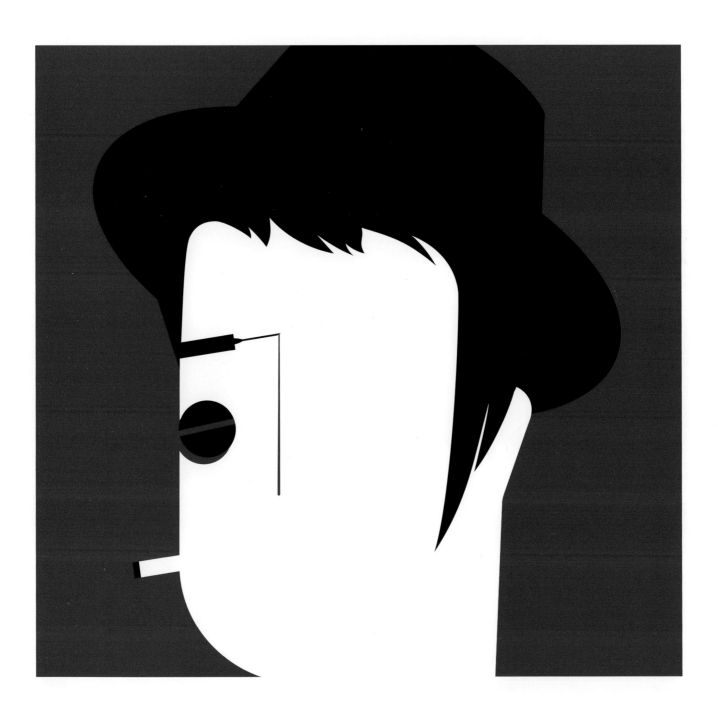

Over the years, Michael Jackson has made headlines for an array of reasons, from number one hits to run-ins with the law. Here, Bar riffs on Jackson's purported pedophilic tendencies, by placing an image of a young child in the pop star's face. Jackson has never been found guilty of these accusations in a court of law, though the media frenzy that surrounded the case seems to have made the eccentric icon that much more reclusive.

In the long-standing tradition of caricatures, Bar's work focuses on the faces of his subjects. This drawing of Luciano Pavarotti, however, is an exception in that the face is a minor part of the image. Renowned for his voice and his appetite, Bar chose to inflate the Italian tenor, reducing his head to the knot holding in the hot air.

TOC	Smiley *33 Thoughts* August 2005		O64	Saddam Hussein *The Guardian* 4 April 2006
O12	Albert Einstein *Esquire UK* December 2006		O68	Kim Jong Il *The Guardian* 10 October 2006
O16	William Shakespeare *Time Out London* 25 June 2003		O70	Ned Kelly *The Guardian* 13 September 2003
O18	Stephen King *Giant* June/July 2006		O72	Joseph Stalin *The Telegraph* 8 January 2006
O20	JT Leroy *The Sunday Telegraph* 19-26 Feb 2006		O76	Hitler *Esquire UK* September 2006
O22	Nick Hornby *Orange* Winter 2004		O78	Margaret Thatcher *The Guardian* 23 September 2006
O26	Tom Ford *Out* May 2007		O86	Ab Fab *UKnow* September 2005
O36	Woody Allen *Blueprint* April 2005		O88	Jamie Oliver *UKnow* January 2006
O44	Bill Murray *Giant* December/January 2006		O90	John Cleese *UKnow* August 2005
O46	David Cross *Giant* December/January 2006		O92	Ricky Gervais *Giant* July 2005
O50	Kevin Bacon *Giant* June/July 2006		O94	David Beckham *Freeserve* Winter 2003
O52	John Travolta & Samuel L Jackson *Cilichili* September 2005		O96	Jeremy Clarkson *UKnow* June 2005
O54	Rocky *UKnow* April 2005		O98	Matt Lucas & David Walliams *UKnow* March 2005

SPECIAL THANKS
My parents
Dana Bar
& Mia Bar,
welcome to the world.

THANKS
The Prussaks, Tamara & Asa Bruno, Keren House, Rhoda Maw, Julia Cole, Ben Cox, Nikky Wollheim.

AND TO ALL THE ART DIRECTORS WHO GAVE ME OPPORTUNITIES
Ash Gibson at Jack & Giant, Alex McFadyen at *The Telegraph*, Declan Fahy at *Esquire*, Fatima Ahmed at *The Telegraph*, Gina Cross at *The Guardian*, James Grubb, Simon Robinson & Liz Edwards at John Brown Citrus, Martin Colyer at *Readers Digest*, Micha Weidmann & Pat McNamee at *Time Out London*, Nick Vogelson at *Out*, Patrick Myles & Juko Fuwa at *Blueprint*, Penny Gareth at *The Economist*, Kevin Bayliss at *The Independent*, Sarah Haberson at *The Guardian*, Simon Brown at &&&

Buzz Poole, Christopher D Salyers at MBP

& Steven Heller